Learning to Teach Art

THE PROFESSIONAL EDUCATION SERIES

Walter K. Beggs, *Editor*
Dean Emeritus
Teachers College
University of Nebraska

Royce H. Knapp, *Research Editor*
Regents Professor of Education
Teachers College
University of Nebraska

Learning to Teach Art

by

HERBERT S. PASTON

Associate Professor of Art and Design
University of Massachusetts

PROFESSIONAL EDUCATORS PUBLICATIONS, INC.
LINCOLN, NEBRASKA

Library of Congress Catalog Card No.: 73-80971

ISBN 0-88224-046-3

Contents

Introduction

The outcome of the study reported here is a guide for student teachers of art in both the elementary and secondary schools. It was mainly the writer's growing concern for quality teaching of art in our elementary and secondary schools, heightened by "the radical reorganization of teacher education and the virtual chaos in student teaching programs in some states,"[1] on one hand, and the current lack of guidance material available for student teachers of art, on the other, that encouraged him to write this book for student teachers of art.

Although there are many current diverse views representing widely different approaches to higher education, many educators and administrators agree that student teaching is (or should be) one of the most valuable educational experiences that a teacher education program can provide for its students. Yet, this aspect of the program is inadequately provided for in some programs. Also, in contrast to the wealth of professional literature concerning student teaching in other areas of the curriculum, there is little written specifically for student teachers of art, and there has been a great deal of expressed need for such help. The only book published on the subject of student teaching in art (1960) does not meet the needs of student teachers today largely because it does not deal with the human aspects of art teaching which this writer feels are essential for effectiveness.

In order to develop this guide, it was necessary for the writer to draw information, ideas, and inspiration from at least three major sources: (1) the writer's continuous personal experience as a college supervisor of student teaching and as a practicing artist-teacher in a variety of educational institutions including private art colleges, state colleges and universities, and graduate schools; (2) extensive discussions with art teachers, student teachers, supervisors, cooperating teachers, and school administrators; (3) examination of the professional literature, including recent studies and research largely in the areas of art, art education, and student teaching, but including other contributing fields as well.

It is hoped that the book will bridge some of the gaps that may have existed in the professional preparation of art teachers at both the secondary and elementary levels by discussing, analyzing, and clarify- practice of art in the college setting to work as full-fledged, independ- ent art teachers in the schools. Although these student teaching pro- the student teaching program.

Today, most programs in professional education concerned with the instruction of art teachers provide some kind of opportunity pri- marily devised to help students make the transition from theory and practice of art in the college setting to work as full-fledged, independ- ent art teachers in the schools. Although these student teaching pro- grams now vary from state to state and even from college to college, we find many of them moving toward the goal proposed recently in a position paper of the National Art Education Association in which is discussed the "Essentials of a Quality Art Program." It is recom- mended that "the student teaching internship programs in the prep- aration of art teachers provide the opportunity of observing and teach- ing for a minimum of eight weeks daily in the classroom, total school and community."[2] Some colleges consider this aspect of teacher preparation so important that they go well beyond these minimum recommendations.

The guide is also intended to help student teachers of art to be- come aware of the purposes and nature of the student teaching pro- gram and to help clarify and reinforce their understanding of the experiences they are about to encounter, thereby increasing the ef- fectiveness of these experiences.

Further, a secondary but important aim of the book is to assist cooperating teachers, school administrators, and members of the faculty in understanding the goals and responsibilities of participa- tion in the art education student teaching program.

Hopefully this book will relieve students of many of the anxieties that are typical of those of the beginning student teachers and stimu- late them to become more comfortable participants in the program. For a program to be effective, students should know what kind of ex- periences they may anticipate and what is expected of them within these experiences.

Student teaching usually is scheduled into the life of a prospec- tive art teacher when he has the need in his professional education to set aside the theoretical issues in order that he can grasp teaching as reality. It provides him with the opportunity to find practical expres- sions for his goals and establish his identity as a teacher.[3]

Since the professional preparation of art teachers may vary ex- tensively, depending on the type of undergraduate school they attend,

as well as on state and local certification requirements and procedures, the first three chapters in this book explore and analyze some of the fundamental concepts and values basic to all art teaching at the elementary and secondary levels. Chapters 4, 5, and 6 deal with a number of realities of classroom teaching, including observation, planning, and implementation. The remaining chapters are largely concerned with human and professional relations and aspects of evaluation.

It is likely that some students with extensive and thorough professional preparation in art teaching will use this book, for the most part, as a review and source of reference. Other students may find it provides guidance in a more practical and concrete way. To cooperating teachers and school administrators it presents an over-view and analysis of current philosophy and practice of art teaching.

A special attempt has been made to structure the guide in such a manner that it may be as practical as possible without setting up hard and fast recipes for "how to teach." It is hoped that students will consider the ideas and suggestions presented as vehicles to speed them toward the discovery of their own best ways of teaching. Therefore, while it is true that the guide is designed to provide a practical and useful source of classroom techniques for student teachers of art, it does not purport to be a text in art education. It is primarily intended as an orientation to, and stimulus for, good art teaching.

Many educators today believe that student teaching should not be the "culminating educational experience" but should instead be placed just before full-time internship in some fifth-year program. A number of states now have five-year programs, and more are considering adding a fifth year. The Report of the Commission of Art Education points out that several institutions are moving in this direction in order to provide the most complete curriculum for the preparation of art teachers.[4]

The development of this new direction could increase the value of this book by extending its use to post-student-teaching experience. In situations where internship programs do not yet exist, the book could be of continued use to the student teacher during his first year of professional service.

Just about everyone agrees that your student teaching experience is—or should be—one of the most valuable educational experiences that a college can provide for those of you who want to be future art teachers. Years from now, you, like so many teachers before you, will probably look back upon your student teaching as the one educational experience which has had the greatest influence on you as a teacher.

This book is an attempt to help give you a good start, by discussing and analyzing some aspects of student teaching in art. The content includes many important facets of student teaching, from theories on art education to class management and lesson planning. A special attempt has been made to structure the guide so that it may be as practical as possible without setting up hard and fast recipes for "how to teach." It is hoped that you will consider the ideas and suggestions presented here as vehicles to speed you toward the discovery of your own best ways of teaching.

Although the book has been designed to provide you with some useful information and ideas about student teaching in art, it is not meant to take the place of texts in art education, with their thorough, in-depth study of all aspects of art education from preschool to high school. It would, of course, be especially helpful to you if you use the Bibliography and other references as points of departure for in-depth discussion and study. Furthermore, the book reflects the points of view of many people as well as the author's and is intended primarily as a stimulus to good art teaching. You should, therefore, consider the book as a starting point for discussion and action, not as an authority to be followed blindly. In the last analysis, only you can explore and discover the challenges and satisfactions, the pitfalls and highlights of teaching art, in a personal way through your own knowledge, your own feelings, and your own experiences.

CHAPTER 1

Why Student Teaching?

As a teacher of art in elementary or secondary schools, you will be asked to fulfill many roles — that of artist, teacher of art, artistic teacher, trusted counselor, and effective administrator.

Since the profession of art education derives its content from art and education, practicing the profession of teaching art requires that you perform both as an artist and as a teacher.[1] If this prospect sounds impossible, it is not. If this prospect sounds demanding and challenging, it is. It is exciting and stimulating and you will soon discover that contact with young minds and spirits is more engrossing and satisfying than you had ever imagined.

Each of you, as you anticipate student teaching, and eventually your first teaching position, will do so with mixed feelings. You will have feelings of excitement and enthusiasm and you may also experience some very disturbing misgivings. Both are to expected and are reasonable. Isn't this the way we approach most of the new and untried experiences in our lives, either personal or professional?

As you think about this new adventure, questions of personal adequacy are bound to loom up. Can I be effective as an art teacher? Do I know enough about my subject? Can I so relate myself to students as to gain their liking and respect? Will teaching art to children and young people with diverse social and economic backgrounds be too difficult for me? If I'm in a situation where there are limited supplies and resources can I make the most of them? Can I inspire students to have confidence in their abilities and to produce worthy art work, perhaps better than I did as a student? Will my cooperating teacher be friendly and helpful and willing to let me try some of my ideas? Will I have enough energy and time to continue my own development as an artist? What are my responsibilities to my school and my college and what do I do when conflicts or misunderstandings arise?

These are just a few of the many questions we will attempt to analyze and discuss in the following chapters.

Regardless of your original motives for choosing art teaching as a career, you can develop a clear and strong desire to be instrumental in the unfolding of aesthetic sensibilities of young people, and you will become more enthusiastic and increasingly confident that art teaching is right for you.

You will continue to develop your understandings and skills as artists while participating fully in your teaching. On the other hand, you may realize that the teaching of art is not the direction for you and that your talent and industry might be more productive in some other area of art or education. Your student teaching then can give you the insight and time necessary to evaluate your motives and goals while you are actually encountering the many facets of your profession.

Up to this point you have learned a great deal about the teaching of art through vicarious experiences. You have read about the experiences of art teachers in a variety of situations. You probably have participated in methods classes in which you explored art media and materials. You may have been in seminars which considered aspects of art curriculum development and lesson planning. Some of you may have had limited observation of students actually at work in their classrooms. Now you have the opportunity to learn more about all of these things through direct experience.

During the process of observation and gradual participation in teaching you will have the chance to implement some of the knowledges and understandings you hopefully have acquired from your courses in child psychology, methods, and curriculum, as well as the many and varied experiences and learnings in the visual arts, and to test their validity or to question them in light of an "actual" situation. Now you will have the responsibility for teaching these understandings and skills to children of many age levels and stages of development who come to you from diverse backgrounds with varying abilities and interests.

You will be able to do all of this while receiving a great deal of help from many people who care about your success in teaching. Your college supervisor, art supervisor, and cooperating teacher will hopefully share your responsibilities for your pupils as they guide you through this experience. They will recognize and encourage your strengths as well as help you overcome any weaknesses. You will receive help in planning your work as well as in evaluating it. The principal and staff of your cooperating school will help you along the way.

The combined effort of all these persons will bring you into personal contact with not only the functions of the art program, but with the operations and interdependence of many facets which make up

the total school program. This is of special importance to you, the student teacher of art, because you are a specialist in an area which is relatively unfamiliar to classroom teachers and administrators, and you could find yourself and your subject isolated from the main current of school and community life.

With this experience and exposure, it will not be long before much of the direction and guidance you received at the beginning of your assignment gives way to increasing self-initiative and self-direction.

You will come into contact with art supplies and equipment frequently used in the elementary and secondary schools which are unfamiliar to you. You may even encounter situations where supplies are drastically limited, as they are in some city and small rural schools, and you will be called upon to use your own initiative and resourcefulness. In other words, you will be able to observe how some of the real problems in the schools are resolved and to contribute to their solution.

Of course, it is quite possible that you could arrive at this point of competent self-direction without the help of all these people. However, at what cost to the young people with whom you work? Sometimes trial-and-error methods can cause irrevocable damage to young minds and emotions. Carelessness and waste of supplies and equipment can cause havoc and hardship in art programs designed to enrich young lives.

Naturally, you will make mistakes with or without help, but you should recognize that mistakes are inherent in the process of teaching and can be extremely valuable if they become signals for steering a more direct course to your goals.[2]

There is no doubt that the teaching of art to young people is highly rewarding, but it is also very demanding emotionally, intellectually, and physically. Nevertheless, if you understand and believe in the values of art to society and art education for the development and growth of human beings, the rewards in personal growth and satisfaction are more than worth your effort and enthusiasm.

In any event, with direction and guidance of experienced teachers and administrators to help you during your student teaching, you will be able to develop more quickly, minimizing your mistakes and multiplying your successes.

Although internship (student teaching) may be regarded for many of you as a coming of age or climax, it is, like other learning experiences, actually part of the ongoing developmental process. Its purpose, then, is not to polish you off as a finished product, but provide you with an open-ended, ever-growing concept of learning.[3]

CHAPTER 2

Qualities of an Effective Art Teacher

Who is a good art teacher? What kind of personality does he or she have? What qualities does he or she need in order to teach art effectively today? What special skills are needed to reach a diverse group of students at various stages of aesthetic and emotional growth? How can one identify a superior art teacher in the classroom? In the following pages we will discuss some of these questions.

One result of current widespread interest in, and concern for, quality art teaching in our schools today has been a real effort on the part of artists and educators to isolate and analyze those qualities necessary for superior teaching. Professional journals frequently publish studies, surveys, and other research material aimed at this effort. The data compiled by some of this research suggests two interesting ideas. First, that many of the personal qualities considered essential or desirable for good teaching by various groups of parents, students, teachers, and educators are the same qualities found desirable in many professions;[1] and second, there seems to be no *consensus* that delineates the *necessary* characteristics of the good teacher.

These conclusions are reassuring for teachers of art, for they once and for all discredit some of the long-held stereotypes and preconceived notions of what the ideal art teacher is or should be like. In fact, they seem to suggest that there really is no one ideal or universal image of the art. At least, at the present time, "as long as teaching remains fundamentally an art rather than a science, particularly in the area of creativity and aesthetics, there may well be no foundation for the systematic listing of tangible and isolated teaching characteristics."[2]

Current opinion does help us, however, by offering us insight into the personalities of effective teachers. If we consider a few of the personality attributes which generally make teaching a socially constructive and personally creative profession, we will soon be able to recognize an effective art teacher when we see one perform in the classroom.

16

FOUR PERSONAL ATTRIBUTES
OF THE EFFECTIVE TEACHER

Ability to Inspire

The influence of an inspired art teacher can be profound. He must somehow strike a spark deep inside his students, enlarging, rather than satisfying, their natural curiosity. The art teacher who can open up a sense of individual capacity and responsibility in his students becomes a guiding force not only in his art room but in the world beyond the school as well. This kind of influence can last for years after the factual content of the course is forgotten by his students or has become obsolete in our rapidly changing world. You know when this inspired art teaching quality exists in the classroom, for there is often as a result a gratifying sense of involvement. The teacher who sustains this climate in which students are free to respond, learn, and create may awaken in them a sense of self-motivation which can develop into a quality of intellectual alertness and aesthetic sensitivity.[3]

It is quite probable that you are a student teacher of art today because of your past contact, no matter how long ago, with teachers — perhaps only one whom you can remember now — who stimulated and developed a sense of self-motivation at a critical time in your life. Since the best and most effective stimulus is that which you bring forth deep from within yourself, it is what the teacher did to help you motivate yourself that was critical. Of course, the ability of a teacher to inspire his students would be highly desirable in any subject area, but it is particularly important in the teaching of art because the very nature of art is so subjective and the art product often reflects the student's depth of involvement and his ability to successfully express the feelings and ideas that seem most important to him. In other words, his very self, as revealed in his art product, is so visible and tangible.

Empathy

Empathy, or the ability to feel deeply for others, is, like many human characteristics, a desirable attribute in many professions. When we relate compassionately to our fellow human beings, we can understand their struggles and aspirations, as well as their needs and limitations, on a personal level and are able, therefore, to develop a kind of rapport which is both open and mutual. This capacity to empathize can have a direct bearing upon the art teacher's ability to select

the most appropriate motivation and encourage the most rewarding kind of art activity.[4] Therefore, it is of special importance that the teacher of art be capable of identifying himself with the interest and needs of those he teaches. The importance of this is reinforced when we realize that the art teacher has the opportunity to work with his students for only short periods of time over the school years, as compared to teachers of the other subjects in the curriculum which are required of all students from first grade through high school.

The result of this kind of rapport and understanding can be seen not only in the quality of the students' efforts in art, but in their overall spirit, interest, and vitality. This teacher understands the struggles and satisfactions, the failures and successes of his students firsthand because he has experienced many of these same feelings countless times in the past while working through the same or similar creative problems of his own. His students sense this kinship based on respect and understanding, through the art teacher's response to them, first as human beings, and then to their art work. It is through such empathy that the teacher of art is best prepared to direct learning in relation to the genuine needs of his pupils.[5]

Knowledge

Although the effective art teacher needs many kinds of understanding, surely one of the most important is the knowledge of the subject of art, gained through his personal involvement in the activities of an artist. In this way he gains an understanding of the process of creation from the initial idea to the final expression in visual form. This means steady pursuit of his creative efforts with seriousness and depth, rather than occasional sporadic or superficial involvement which would be of little value to the artist as a teacher. There are, of course, many teachers who provide art lessons for their classes who are not practicing artists in the full sense of commitment, particularly those who teach in the elementary school; but most of the effective teachers at every level have attempted some serious creative work themselves. The experience and understanding resulting from this involvement provides the very basis for his or her functioning as an art teacher.

Another kind of knowledge this art teacher must have, if he is to bring the sense of cultural heritage into his teaching, is great awareness of the traditions of art. He must understand how the arts, current and past, are related to one another. This involves not only knowing facts and information in historical sequence but, more importantly, an

understanding of the meanings and ideas behind the relationship in the arts, if he hopes to bring together knowledge and understanding of the past as well as foster aesthetic and humanistic understanding for the future. He must also continuously reexamine some of the inherited concepts which have influenced instruction in the past (including his own) and be open and receptive to the new emerging concepts which may be vital,[6] because old ideas, by their very nature, cannot and do not change unless they are challenged by new ones. It is this awareness of the changing and dynamic nature of art that gives his students support for their own personal creative efforts.

The effective art teacher must know a great deal about the variety and nature of tools and materials as well as processes. All material and processes have specific characteristics which can offer rich and distinct results. However, along with these unique opportunities for expression, each has natural limitations, also. The art teacher who understands this through personal knowledge is in the best position to know when and how to provide those items in relationship to the age and level of the students who will use them.[7]

Closely related to effective use of knowledge about art media and processes is the art teacher's deep understanding of the nature of learning and human behavior and development. There seems to be steadily growing evidence that all children progress through comparable stages of development in art expression. Knowledge of these stages is, therefore, fundamental for understanding and guiding young children.[8] However, the effective art teacher is increasingly aware of the behaviors of those students at all levels, so that art can make more significant contributions to their education.

Sense of Self-Worth

The successful art teacher often possesses a high degree of ego-strength. That is, a kind of personal courage which helps him resolve (or at least continue to try) the most challenging of teaching situations. This type of personal courage calls for an increased acceptance of self, opening the way for more spontaneous and expressive behavior. Almost all human beings have this potential at birth. Unfortunately, this fundamental characteristic is often dulled or inhibited as we move from childhood into the adult culture.[9] This teacher doesn't shatter easily. He is not discouraged by temporary setbacks in the classroom. He seems to have this deep-seated belief in his ability to do the job and strong confidence in his own future. To him, each challenge is another adventure. This faith he has in himself often frees him to respond

spontaneously and enthusiastically to his students, co-workers, school staff, and administrators. Having such self-conviction gives action and strength to his teaching experience and can form some of the foundation for effective teaching.[10]

CONCLUSIONS

Of the many personal qualities which are both useful and desirable for effective art teaching, four stand out as especially important. They are (1) the ability to inspire, (2) empathy, (3) knowledge, and (4) a sense of self-worth. It is quite possible, however, that the most important traits of all are not even on this list, for they are those personal and individual characteristics which you now possess because of your unique qualities. These will develop and thrive through experience in the classroom, enriching both you and your students.

The art teacher who has many of these qualities stands out and can be recognized immediately in any classroom. He is the teacher who provides guidance and security for his students, without domination. He is the one who frequently plans and evaluates work with his students. He is not afraid to take a chance or to try a new idea. In other words, he is not threatened by failure. He is usually able and willing to experiment with a variety of techniques, materials, and routines. He develops within his students a high degree of self-motivation based on their inner needs and goals. He is careful to communicate on his students' level of development and understanding. He has the ability to interact with other areas of the curriculum and with society in general. He is continually involved in creative activity for his own personal growth and for insight into the creative processes. He is the kind of person who consistently analyzes his own successes and failures as a teacher and is even willing to seek and utilize professional evaluation of others.

If you think this teacher is a very special kind of person—you are right! For, after all, "good teachers are very unusual people."[11]

CHAPTER 3

What Do You Believe?

Why art education? Should a planned program in art be provided at all educational levels, from kindergarten through high school? What about the exceptional child – the gifted and slow learner? Can art help the disadvantaged student? Should we be interested in the aesthetic development of the child? What is the role of expression through art? Is creativity an important goal?

How you answer these questions, and others, depends to a large degree on your philosophy of art education. Even at this early point in your career, you have probably developed a number of concepts about art education based largely upon your experience and observations, the writings, investigations, and studies of art teachers, educators, and others in related fields. Some of these ideas and ideals may have unconsciously developed into what might be called your philosophy. During your apprenticeship in student teaching, you will probably develop more ideas, consolidate some, and possibly drop some. Shortly, you may be observing and working with art teachers whose actions seem to reflect several different philosophical points of view. Can they all be correct? Is there only one proper philosophy of art teaching? Perhaps a brief survey of some of the factors which have influenced the development of art education would help you understand where art education is today and how the field might develop in the future.

THE CHANGING ROLE OF ART EDUCATION IN OUR SCHOOLS

American art education has traveled a long, uncertain road since Benjamin Franklin, in the eighteenth century, first recommended that drawing be included in the school curriculum. Franklin believed that drawing was not only a useful and desirable skill to serve people living in eighteenth-century America but, most importantly, that drawing

could transmit qualities and concepts that even words could not. Unfortunately, Franklin's recommendations did not fare well when pitted against the inflexible educational establishment of the classical curriculum.[1]

As our nation grew, however, so did the importance of art education. By the 1870s, art education programs were introduced into our schools as an aid to improve the skills of the common man in our growing industrial society.

You can trace the movement for art education during this period to the influence of a few men who knew, from European experience, that this country was far behind the times in the promotion of art. They felt that this lack affected not only the commercial prosperity of the nation, but its character as an educated people as well.[2] Through the years, ideas on art education continued to change and develop as well as broaden in focus, reflecting the new ideas and ideals of the changing social and educational scene.

By the middle of the twentieth century, the National Art Education Association, a professional organization of thousands of art teachers, artists, and educator members not only recommended that art be taught in all schools, but also that "art classes should be taught with full recognition that . . . art is less a body of subject matter than a developmental activity."[3] Twenty years later, in 1968, this same association set forth the belief that "art is a body of knowledge [as well as] . . . a series of activities which the teacher organizes to provide experiences related to specific goals."[4] These changes are largely in emphasis and scope, and are brought about by the continuing dynamic forces of twentieth-century society, together with the basic readjustments in the whole field of education.

In discussing changing goals and art education, Arthur Foshay points out:

> Any subject matter has to justify itself according to how generalizable it is, how universal it is for the general education, and how feasible it is. No subject matter deals with man as the arts do, and he who fails to grasp the reality of this aspect of the human conditions is less than a whole man; and is therefore less than wholly educated, since the art experience is a part of all perception, the argument for art as a part of general education is unassailable.[5]

While it may be acknowledged that art education has made great strides in our schools in recent years, it should also be recognized that in practice today the arts are still treated as marginal in many of our educational programs, and there are but a few educational curricula

which provide a knowledgeable involvement with art for everyone from the nursery school on.[6]

A report of the National Education Association, *Music and Art in the Public Schools*, points out quite clearly that large numbers of students at the elementary and secondary levels have no art instruction at all.[7] You need only to reflect upon your own educational experiences to realize that the arts have been far from the center of your educational program from kindergarten through the university.

This is true in spite of the fact that the need for art education in our society has never been greater. We are living in a time when the objectivity and materialism of technology desperately needs to be balanced by the subjectivity and humanizing values of the arts. In this age of regimentation and conflict, what could be more essential than the recognition and respect for the individual, a concept which is fundamental to the arts![8]

It would be most helpful for you, as a future art teacher, to develop and refine your own philosophy of art education. You should become familiar with the rationale and goals of art education in today's schools as well as some of the divergent theories and practices of art teaching. Of course, further, in-depth examination of these ideas and development would be useful to those of you who have not examined them in your college courses. Remember that all too soon most of you will be responsible for planning your own art education programs and therefore it is important that you have a clear and broad understanding of past and current theories and practices for the use they can be to you in making knowledgeable decisions about your teaching of art in the future.

RATIONALE FOR ART EDUCATION IN OUR SCHOOLS

Through the visual arts, the individual is involved in understanding the world he lives in, thus encouraging him to react to the things he sees and feels. When he interprets these feelings, emotions, and insights through visual materials, he can often influence not only himself, but the community and culture as well; for when we express our ideas in art we involve ourselves in both the examinations and appraisal of works of art and the development of aesthetic problem-solving behaviors.

Art, then, can provide the balance in school programs which now place primary emphasis on science and the three R's by providing

the student with the opportunity to develop creative and intuitive approaches to problem solving.[9]

In order to make each aspect of art which fulfills his particular needs and potentials available to each individual, a pluralistic program should be offered in each school system—indeed, in each school. A multi-faceted program of this type would also allow and encourage each teacher to contribute that which he can best give.[10]

Of all the contributions a good art program can make to the education of your students, perhaps three stand out as especially urgent in society today: "(I) The development of personal expression; (II) The ability to make qualitative aesthetic judgments; (III) Recognizing the role of art as a means of understanding cultures."[11]

Development of Personal Expression

Stress on individuality, of course, has always been one of the unique and traditional characteristics of the arts. It is basic to the arts to emphasize individual interpretations and expression. Man has always attempted to give form to his ideas and feelings and to gain personal satisfaction through individual unique accomplishments.

Qualitative Aesthetic Judgments

By providing aesthetic experiences as part of the art program your students will understand beauty not as some kind of internal or external state, but as a dynamic quality in their changing and developing responses. The goal of aesthetic experience is a full, rich life for the individual, and today, as in the past, man has often used the arts to build and enrich his personal as well as shared environment. Art experiences in schools should help your students understand the visual qualities of their environments and should lead to the desire and the skill to improve the aesthetic quality of their personal and community living.

This is a period of rapid technological development and social change, when our values often depend on rapidly changing styles, quick turnover, change simply for the sake of change or just to keep up with the "Joneses" instead of critical thinking. It is particularly important today that every individual, whether he produces works of art or just lives with them, develop the capacity for visual discrimination and judgment. Society offers us an increasingly confusing range of choices. Our capacity to make decisions and to exercise rational and personal choice in our mass society is now critical. Developing positive

attitudes which can guide us even in the midst of change is certainly one of the major challenges of art today.

Art as a Means of Understanding Culture

The values and beliefs of a people are visible in the art forms they have produced. You need only to examine the cultures of ancient Egypt and Greece, medieval Europe, and Renaissance Italy to find that art tends to be in the vanguard of cultural advance.

In some instances, as in the case of the ancient cavemen, we find that their art is all we know of them.[12] A critical examination of the art forms of cultures past and present can lead to a better understanding of these cultures. It is relevant, therefore, that your students have a knowledge of art objects in relation to the culture which produced them, as well as of our culture today.

OBJECTIVES OF ART EDUCATION PROGRAMS

When we search for objectives of a total school art program, we realize that certain broad experiences should be provided for all. However, it is important to remember that students' needs and abilities should determine the emphasis and depth of the art experience itself. Since the interest as well as the intellectual, social, and aesthetic maturity of each student must also be considered, you can readily understand why not all of the art experiences should receive the same emphasis at each level or with each student.

Any dynamic and meaningful school art program should include (1) the making of works of art, (2) the knowledge of art objects and their makers, and (3) the evaluation of art products. Within these broad classifications of experience, each student should (to the extent that he is able) have intense involvement in, and response to, personal visual experiences. He should be able to discover and understand visual relationships in the environment. He should be able to think, feel, and act creatively with visual art materials. His skills in manipulation and organization should increase, as should his knowledge of man's visual art heritage. The use of art knowledge and skills in his personal and community life should become evident. Within the limitations of his experience and maturity, he should be able to make intelligent visual judgments. Finally, he should show signs of understanding the nature of art and the creative process.[13]

These objectives are widely recognized and accepted by many art teachers in the field today. During your student teaching experience, however, you will find that teachers vary in the methods they employ to reach these goals. The sequence and depth of art experiences are determined by the art discipline, the objectives desired, and by the interest, abilities, and needs of children at different levels of growth. Individual interpretation of these factors contributes to the variety of art teaching practices we find in classrooms. This variance, however, often reflects the different emphasis and degree of intensity given to some goals over others by individual art teachers, rather than disagreement with the overall aims themselves. Actually, these contending ideas and emphases are stimulating to some art teachers who believe this diversity is an indication of the vitality of the profession. On the other hand, you, as a beginning teacher who is seeking the best methods for implementing the aims of art education, may find it bewildering.[14]

EXPERIENCES ESSENTIAL TO A
QUALITY SCHOOL ART PROGRAM

In order to achieve the goals of art education which have just been discussed, a quality program must be developed and practiced at every level from the elementary school through the university. While the overall experiences should satisfy the major objectives, they must also provide the flexibility needed in order to implement individual lessons or units dealing with specific goals.

You can recognize a program which provides these broad experiences by observing what occurs in the art room day by day. Such a program will provide both man-made and natural objects from many different sources for student examination. A variety of art materials suitable to the manipulative abilities and expressive needs of the students will be available. There will be exploration in depth with art materials and processes. Students will work with a variety of tools in order to develop manipulative skills necessary for satisfying aesthetic expression. Ample time will be provided for organizing, evaluating, and reorganizing work-in-process to gain an understanding of its formal structuring of line, form, color, and texture in space. Students will not only look at and read about works of art, but will also discuss them. Educational media and community resources will be used to reinforce this effort. The art work of students, mature artists, industrial products, and home and community design will be evaluated. Finally,

there will be many opportunities for the students to apply their art knowledge and aesthetic judgment to their personal lives, their homes, and their communities.[15]

No consideration of goals and objectives of art education would be complete without attention to several special aspects. Although they are discussed only briefly here, many of you will find that your particular student teaching situation now or your teaching situation in the future will require more intensive investigation into one or more of these areas.

ART EDUCATION AND THE EXCEPTIONAL CHILD

Very early in your student teaching you will become aware of the fact that some of the students you work with seem different from the majority. Because these students are exceptions to general expectations and because of these differences they are called exceptional. Included in this broad category are the artistically gifted, academically gifted, the slow learner, physically handicapped, and the economically or socially disadvantaged. In some schools, and with some subject matter, these students are separated from the "average" or "normal" children and put into special classes or sections – in the care of teachers with highly specialized preparation. There are numerous situations, however, where these exceptional children are a part of the average class. There are also instances where the exceptional child has not even been clearly identified. It is likely that you will come upon one or several of these situations or a combination of them in your student teaching, particularly in the teaching of art, where special grouping is not a frequent occurrence. It is especially important, therefore, that you recognize the many ways these "exceptional" children and young people are like "normal" or "average" students and also how they differ from them. Preparing yourself to meet the special needs of all your students is a basic responsibility of teaching art in our schools today.[16]

The Artistically Gifted Child

Although it is now possible, through recent and continuing research, to identify intellectually gifted children and young people, we have not yet been able to account for this special ability in art nor explain why the differences between the gifted and average child occur. We do know, however, that children who demonstrate unusual art

ability usually are above average in intelligence, suggesting that general intelligence enables the individual to utilize more effectively the art ability he possesses.[17] We also realize that because gifted children are more resourceful and inventive than the average and have high-powered intellects to guide their efforts in the arts, they need a wise teacher who knows how to encourage and direct the development of their talent.[18] It is important, therefore, that you understand the special gifts and needs of the talented students in art in order to help them develop to their highest potential. If you are able to recognize these special abilities, you should be better equipped to guide average children in the fulfillment of obtainable goals, also, rather than pushing them beyond their ability.

We find that the child gifted in art—

Is usually beyond the norm of his age group in developmental status, technical skill, and aesthetic judgment;
Excels in compositional arrangement, enrichment, and in decorative and aesthetic qualities;
Handles art media with great ease;
Is quite adept in representing movement;
Brings a strong visual point of view to the content of his art work;
Is able to retain impressions of things he saw a long time ago;
Frequently changes and enriches his schema;
Seeks out explanations and instructions;
Is responsive to unusual subjects in art;
Often excels in several qualities in the same work of art;
Is concerned with design and technique—rather than subject or realism of presentation;
Tends to identify himself less with actual subject of his work;
Is less influenced by association and personal reasons and tends to judge art work in terms of technique;
Is more aware of the possibilities and limits of media and adapts technique to the medium he is using.[19]

These are, of course, just a few of the characteristics which have been identified. On the whole, however, "there appears to be no radical difference in kind between the gifted and the average child in art but, rather, a gradual stepping up of a number of related abilities plus a strong tendency to experience things visually and even to try to suggest, represent and symbolize types of experience in visual terms."[20]

Experience in the visual arts for these gifted children need not be completely different and separate. It should, however, be a more

complete and intensive development of his combined specific talents to their fullest capacity. Critical thinking, self-evaluation, and careful discrimination become equally as important as the exploration and development of ideas and the use of material and tools.

The child or youth gifted in art needs many opportunities for problem-solving and experimentation as well as independent work which would encourage intense, in-depth experiences. Teaching the gifted is perhaps best approached by establishing a permissive atmosphere under which the entire class can benefit from open-ended, self-guided experiences, as opposed to more structured lessons.

Since you have chosen art teaching as your career, you are probably a gifted student in art yourself! You will experience great rapport and stimulation working with these gifted young people. You will feel especially challenged and encouraged and want to be as helpful as you can. At the same time, you must not lose track of the fact that every member of your class needs and deserves your attention and encouragement. A well planned art program can provide for the challenge of the gifted, at the same time assuring all your students that you are not favoring one group at the expense of the others.

Art for the Academically Talented Student

One recent and healthy development in this period of reevaluation of general education has been a growing concern for the education of our academically talented students. There has been a tendency in the past to give students with high I.Q. ratings of 120 or more or those with reading ability well beyond their age-grade level a highly verbal education which involved only the intellect. Programs are now being developed to meet the special needs and abilities of this group which are not only intellectual but emotional and intuitive as well; for "all academically talented students profit from instruction in art involving abstract ideas and historical contexts as well as personal experience in appreciation and creation."[21] It may be difficult for some intellectually gifted students who have been highly successful in many academic pursuits to realize their "product" in the art class is not as important as the "process" of problem-solving, manipulation of materials, and their personal emotional involvement. An art program for these students might place special emphasis on processes. On the other hand, of course, some students may be both intellectually and artistically gifted. Since a large number of the future leaders in all phases of American life will come from the academically talented students, it is important that these people develop every aspect of their human capabilities.

Art for the intellectually gifted is more than just a pleasurable exercise, for it encourages those who are best qualified to delve into the unknown, to probe the unusual, and to find satisfaction and pleasure in exploring areas where the directions and answers are found only in the self.

Art Education and the Slow Learner

During your observation and student teaching, chances are pretty good that you will encounter, either as a group in special sections or individually in general classes, students who are identified as "slow learners" or educable mentally retarded. Since 12.4 percent of all school children can be regarded as exceptional in this way, it is important for you to recognize their likenesses and differences from "normal" children so that you are able to provide for their special needs.[22] This is not an easy task, since, on the surface, some of these children do not appear to be handicapped. Other classroom teachers, guidance counselors, and student records can be helpful in providing you with information about these students. The more aware and sensitive you are to their special needs, the more able you will be to help them.

It is essential to remember, when planning an art program for the slow learner, that, although he draws like a normal child of the same mental age who is chronologically younger, the rate of development is slower. A well planned art program and an understanding teacher can lessen the fears, tensions, and feelings of inadequacy that these students often have, as well as aid in better physical coordination, improve their manual dexterity, and even help their social adjustment.

Success of an art activity for the disturbed child does not necessarily mean the completion of the project, but, rather, the feeling of success in each child. For one child this may be merely the accomplishment of actually handling the materials; for another it may mean the completion of one step without adult help. When material can be introduced in both verbal and non-verbal ways, the activity will have a greater chance for success. Selection of art material and activities for this type of youngster is most important because their reaction to materials can be unexpected and sometimes upsetting. The mediums of clay, finger and tempera paints, soft chalk pastels, large sheets of paper, and large easel brushes offer a sense of success to these students.[23] Most retarded students are not only able to derive substantial benefits from participating in a program of art education, but their interest and ability in some phase of art activity may well be one of their strongest and most satisfying assets.[24]

Art Education and the Physically Handicapped Student

Art holds an important place in the education of physically handicapped students because it offers a sense of satisfaction and achievement to those who cannot participate in strenuous and active forms of recreation and social involvement. An art program can help some handicapped children overcome feelings of failure and inadequacy by encouraging them to try new experiences through patience and acceptance of their limitations and by modifying the art media to suit their individual physical restrictions.

Art activities should be planned in such a way as not to exaggerate or dramatize the particular handicap because, when handicapped children have interests in common which contribute to their sociability, they are most contented and gratified.[25]

Art Education and the Disadvantaged Child

"Disadvantaged children come from widely varying socio-economic backgrounds. Some are urban; some sub-urban; some rural; some are permanent residents; some have moved frequently; some are migrants. Many suffer socio-economic deprivations; many are rejected for racial, ethnic or religious reasons."[26]

You will probably meet some of these children during your student teaching assignment. How can you and a program of art education help these young people who come to the schools with firmly established negative self-concepts and wide experience with failure?

The disadvantaged child cannot be helped until those who are educating him realize that his needs are different and that he, therefore, needs a different approach to his education. You must broaden your own knowledge if you are to teach these children effectively. Since many of them are emotionally deprived and have different views on home life and family roles than their middle-class peers, they may need special understanding and attention before they will be able to be open in their art work.

By becoming familiar with the role of various racial, ethnic, and religious groups in developing the cultural heritage of our nation, the art teacher can help his students find new meaning in their past and new identity in their present.

A well structured art program can help these students first by providing much-needed sensory education. Art education, which begins with and depends on the senses, can enrich the lives of all children — in fact, of all human beings. However, a heightening of aesthetic experience for the disadvantaged child is a necessary step to fill the limitations of his special environment.[27]

Art can also help in the development of the child's cognitive processes by encouraging him to reproduce in his own particular way the experiences that have meaning to him, "rehearsing, reproducing and symbolizing his experiences as the foundation of thinking."[28]

Art can further contribute to the strengthening of the child's positive self-image through special projects such as puppetry, which can also be used for language development as well as improvement of social skills in the classroom. Other programs in art might be centered on the history, traditions, and culture of a particular people.[29]

As yet, there is no consensus among art educators as to the "correct" direction art programs for the disadvantaged minorities should take. One group believes art education should be the same for all children—including the disadvantaged. Some stress that all children should learn of the contributions made by different groups to the mainstream of art in the United States. Others believe children may gain a sense of worth through studying in depth their own art heritage.[30]

Many educators who have been working with disadvantaged children do agree, however, that these children working in art may need to start by learning in familiar ways and may feel threatened by too much emphasis too soon on self-direction and self-expression.[31]

All art programs can have a powerful and positive effect in helping disadvantaged children form richer and more meaningful attitudes toward their environment and themselves when they are conceived and implemented by concerned and knowledgeable teachers who are able to see students as individuals rather than as members of disadvantaged groups. Moreover, these teachers are most effective when they understand and use process-oriented techniques and a wide variety of appropriate media and materials.

CONCLUSION

Thus, we find that education in the visual arts can be of great value to all children and youth—including not only the so-called "average" students, but the artistically talented, the academically gifted, the slow learner, the physically handicapped, and the disadvantaged as well. We know that the benefits of children's art experiences will be revealed in their adult attitudes and behavior. Art not only provides young people with the opportunity for personal development and self-realization but is also concerned with active experience, discovering, and understanding through problem-solving activities.

In this materialistic age, the non-materialistic nature of art is essential because it offers unique opportunities for individual expression in a time when we are all subjected to society's pressures. Since the nature of man denies materialism as an end in itself, the arts strike a responsive key in man's search for humanism in the community of man. To be truly educated, therefore, all students should, throughout their years of formal education, have some guided experiences in the visual arts and in most instances the educational function of the visual arts should be central rather than purely peripheral.

CHAPTER 4

Observation — The Art of Seeing

IN THE BEGINNING

Since patterns of student teaching in art differ, it would be impossible to include in this book all the situations or combinations that you might encounter. Most colleges, however, provide their own general guide or handbook prepared by the office of student teaching with the assistance of the college staff, which is designed to assist you as you enter this critical phase of your education. It usually contains a discussion of purpose and policy as well as specific requirements and assignments. If your college art department does not have one, you should see if one is available from the student teaching office in the school of education.

The school or district to which you are assigned may also have a guide which will discuss the total school curriculum, the scope and sequence of the art program of studies, and the extracurricular program. Guides of this type frequently state the objectives of the school and the characteristics of the school population and community.

All student teachers find these guides helpful, but they can be of special value to you, as an art specialist; therefore, you would do well to read them carefully. You may be required to work with a large cross-section of the student population — if not the total population — and particularly in the elementary areas, not only in one school but several schools. You may also be asked to help with some extracurricular activities involving not only the students but the parents, the faculty, and the community as well. The more you know about the total program, the philosophy of the school, and the nature of the community, the better able you will be to understand what you observe and experience and to cope with some of the problems when you do your own teaching.

Since no student teaching is the same for every student teacher and no two student teachers think and respond the same way in any

one given situation, no one can predict exactly what you might find when you first enter your cooperating school. Most cooperating teachers are delighted that you are there and show it; others seem less friendly. Some schools have special art rooms, well equipped and supplied; others have inadequate facilities and meager supplies — with little hope of improvement. Many school systems have intelligently planned experiences prepared for you — yet there are those schools that seem unprepared or indifferent about your visit.

It is hoped that you have an "ideal" situation; that you have had an opportunity to meet the school principal and your cooperating teacher at an earlier visit; that you have a tentative schedule, necessary class outlines, and a good idea of some of the equipment, supplies, and facilities available to you; that you are expected on your arrival, welcomed, and introduced to your students as a fellow teacher by your cooperating teacher; and that you are generally made to feel comfortable in this unfamiliar role of art teacher.

On the other hand, even if your situation seems less than "ideal," you will come to understand the many complex reasons which bring about poor planning, indifference, and unfriendliness, and poor equipment, supplies, and facilities. Through your interest and performance you will soon discover that even you, from the very beginning, can exert a positive influence which will not only help your immediate situation, but will also prepare you to deal effectively in other situations as a future art teacher.

Your success as a student teacher of art, therefore, depends primarily on you. If you can demonstrate through your words and actions that you are a responsible, serious person, willing and eager to learn (rather than someone who knows it all), and have a genuine concern for children and their education (not only art education), you will gain acceptance and respect of your students, your co-workers, and your supervisors.

Observation

The first week or two in any student teaching situation is the time to become acquainted with the students, the classroom, the school, and the community in which the school is located. What you observe and what you experience these beginning days will have a direct influence on what you plan and do as you assume your teaching responsibilities. By keen observation and analysis you will be able to extract every possible learning opportunity from the teaching situation.

The Community. Note the type of community in which your school is located. What resources are nearby that you might use in your art program? Are there special places of interest such as a museum, a greenhouse, a zoo, a bridge, an interesting landscape or landmark? Does the community use the school for special events and activities such as scouting, PTA meetings, plays, and civic groups? By knowing as much as you can about the community you will be able to plan for special interests and events as well as for the particular needs of your students and their parents. Art programs can play a vital role in the community only if art teachers realize and seek out opportunities.

The School. 1. Locate the library — you will probably want to use it for your own planning and to recommend students to it for special reading and assignments. Examine the books and periodicals on art. Become familiar with those you don't know well and make a note of those you think a library in this situation should have.

2. Know where the nurse's room is located. Accidents can happen when you work with tools and equipment in the art room. Fast and decisive action under these circumstances can prevent serious injury and complications.

3. Visit the teachers' lounge, if there is one. You may find it the hub of the school, with teachers engaged in lively discussions of everything from their last classes to the morning headlines. This is a good place for you to keep your eyes and ears open and really get to know the scene. It is not, however, the place to discuss your personal problems, or to criticize your cooperating teacher or the school system, or to expound at length the other gripes you may have on your mind. You'll be glad that there is a place for you to go and "unwind" a bit during a hectic day. It's also a good place to meet some of your coworkers and to get to know them in a relaxed, informal atmosphere. Introduce yourself as a student teacher of art and before long, some of your feelings of isolation will disappear and you will find yourself accepted and comfortable.

4. Investigate special services available, such as audiovisual and special equipment. Most schools will have some instructional material and resources available which will be useful to you in planning your art activities.

The Art Room

It is here, in the classroom (a regular classroom in which art lessons are taught at regular intervals during the year) or in the art room

(a special room assigned for art work, to which classes come for art work), that you will spend most of your time observing and teaching.

Elementary Level. Many of you will do your observing and teaching in a regular classroom at the elementary level. The class will have one assigned teacher who teaches all subjects (with the possible exception of special areas such as art, music, and gym) to one group of children for a year. The subject of art is usually taught by an art specialist (your cooperating teacher) who may teach all the art in your building or in several schools. On the other hand, he or she may be the art supervisor for many schools in the system and therefore will teach only some classes and perform as an art consultant for the rest of the classroom teachers.

There are still other elementary situations which have a special studio room for art, similar to those often found in the secondary schools.

Yours may even be one of the few schools which schedule their art activities for early mornings and late afternoons so that they can use the large space and table area of the cafeteria for art work.

While the physical facilities of some of these elementary school situations may strike you as less than ideal, and radically different from your most recent studio environment, you will nevertheless be astonished at how imaginative art teachers have overcome some of the tough problems of space and organization and are able to provide exciting and meaningful art programs. It certainly suggests that, even though an ideal physical plant and new equipment are helpful in art, the quality of the art teacher is still the vital force in a quality art program. By observing how some of these problems are faced and resolved—or not resolved—and by thinking of what you would do to solve these problems if this were your class, you will be better prepared to deal with these or similar difficulties should you encounter them during your future teaching.

Secondary Level. At this level you will probably be assigned to one or two art specialists who teach all of the classes in one or more rooms specifically designed for studio work. These rooms are sometimes connected or grouped in the "art area" of the school building near the industrial arts and music rooms.

In high schools where there are "art major" programs you are likely to find well equipped and highly specialized facilities. There may be a ceramics room, a printing room, a painting studio, and even special areas for mechanical drawing, photography, and sculpture. In many respects these situations will be closest of all to your own recent

studio experience in college. Here, again, there may be great varia-
tion from school to school. Some provide facilities—in a few cases,
better than your own college. Others leave much to be desired. There
is, however, a great deal for you to see and learn in either case. Your
job is not only to recognize and utilize what is good but also to con-
sider what improvements are needed and how you in your own situa-
tion—or even in this one—could work toward that end. You will find
it much easier to recognize what is good than to wrestle with the prob-
lems to improve a situation. Remember, a situation that is less than
"ideal" does not need your criticism as much as it needs your help!

HOW TO OBSERVE IN THE ART ROOM

If you think of education as being concerned with active experi-
ence, discovering, and understanding, you will come to realize that
observation need not always mean a passive looking on. Whether your
observation experience is passive and static or active and dynamic de-
pends largely (although not exclusively) on you.

Don't always wait to be given assignments but volunteer on your
own account to do small things. Your attitude of willingness and in-
terest will be appreciated by your cooperating teacher. It's also a good
way of "breaking the ice" or feeling your way around in a new situa-
tion. Ask if you may arrange a bulletin board within the context of the
work in progress or on something seasonal or current. If you are alert
to the opportunities to help—even if it's only running an errand, dis-
tributing art supplies, or cleaning up after a studio experience—the
more you will learn.

You might offer to bring in films, art reproductions, and books
from your college art department or from your own special sources.
When you give generously of yourself and your time in this way—even
in what seems to be unimportant or a menial task—the more directly
you convey your genuine interest and enthusiasm. It's important to
remember that some of the most valuable insights come about through
indirect and casual activities such as these, and these experiences
frequently open doors to other opportunities to learn.

WHAT TO OBSERVE IN THE ART ROOM

Observing Your Students

These first weeks of observing in the classroom are ideal for you
to become acquainted with your students in an informal way. You have

not yet assumed full authority or responsibility for the art lessons, so you are free to concentrate on watching the students perform in the classroom, respond to the lessons, and relate to one another. This semi-detachment gives you an overall perspective of the situation which is sometimes harder to gain when you are under the pressure of planning and teaching the entire art lesson. Because your childhood was so long ago, you can't exactly recall how it felt, what you thought, and why you acted the way you did. At any rate, the students today are far different from those of even a few years ago. Of course, your child-development courses have helped with certain understanding of what makes students act as they do, but live observation and listening are still the best source of all. Try to see the world through their eyes. The failure of a teacher to see and understand his students as individuals and as groups can lead to classroom discipline problems in the future.

What are the students really like? How about their sense of humor? What do you know about their language, their interests, and their dress? See if they wear special clothing for certain messy art activities (old shirts, smocks). How do they handle materials, equipment, and tools? Because of the nature of some art activities, students frequently talk to each other and move around the room freely. What are their conversations about (their projects, last night's television program)? Try to identify the students who differ from the so-called normal. How do these exceptional students respond to their classmates, the teacher, and the lesson? Because of your vantage point as an observer you can more easily spot the student who did not hear or understand the instructions and seems to be floundering. Moving around the room, giving individual help, reinforcing the art teacher's objectives, even expressing an encouraging word and giving a sign of recognition can be very helpful to the art teacher, as well as to the students, and can add to the success of the entire lesson.

Take note of the changing personalities presented by any one class from day to day. You may be surprised to see the class very enthusiastic about a particular lesson or art material one day and completely apathetic about everything the next day. Listen to the students' problems, gripes, and ideas, but don't allow yourself to be monopolized by one or two, or permit the students to use your presence as a distraction from the lesson. What kinds of questions do the students ask? Are they asked for information or to sidetrack the teacher? Do many students get a chance to answer questions and help distribute and collect materials, or are a few students chosen most of the time?

You will probably find the range of student differences greater than you expected. Some will fit into your picture of what a particular

grade- or age-level child should be like, but others may surprise you. Can you recognize the alert, gifted, talented child, the class clown or the chatterbox or the listless and withdrawn student? You will soon discover that your preconceived stereotypes of students will become less valid as you continue your observation.

Observing the Teaching of Others

Finally in this discussion of observation, but possibly foremost in your thoughts, is the observation of the art teacher (in most cases your cooperating teacher). It is mentioned last, not because it is unimportant, but because student teachers frequently place too great an emphasis on it, to the exclusion of the other aspects of observation. You may have the opportunity to observe the classroom teacher, or art teacher, art supervisor, and occasionally a substitute teacher in action. Most of them will be experienced art specialists, frequently chosen to be observed because of their skill in art teaching and because they are interested in helping beginning art teachers learn.

Observe the teacher first as a person. Are his practices in the classroom consistent with ideas he has expressed to you? How do his voice, speech, dress, mannerisms, and general appearance affect his students? Think about the purpose of the art lesson. Does it have a specific purpose and is it clear to both the teacher and the pupils? What evidence can you find which suggests that the teacher plans or does not plan the lessons with his students? Does the lesson end with a concept clearly established? Should it? Does this project lead into the lesson or activity to follow? What method or methods does the teacher seem to follow? Is the lesson well planned and organized or does there seem to be confusion? Has the teacher used any audiovisual material to reinforce the lesson? Did it help the lesson or detract from it? What seems to be the strength and weakness of the teacher in action? Are the individual differences among his students provided for? Are the questions, assignments, and activities related to the specific lesson or overall program? Is the atmosphere in the class one of self-discipline and group discipline, or is it hectic, noisy, and chaotic? How does the art teacher establish room atmosphere? By concentrating your attention on these and other things the teacher does, you will be influenced less by subjective personality preferences and conflicts which could limit you objectively and color your observation.

Instructional Aids and Materials

1. Check the available textbooks. Some schools use textbooks and special periodicals as part of their art appreciation programs. Become familiar with this literature so that you will know what the students are studying and where they are heading next.

Look over the regular class texts also (literature, poetry, history), especially in the elementary and junior high areas, so that you get to know not only what they are studying, but become familiar with the language level. A common weakness in beginning art teachers is their inability to translate their professional terms and concepts into language that children understand. Reading their books is an excellent way to get the sense of their language level. Several new art publications written especially for children and young people are now available. Classroom teachers as well as art teachers would be pleased to know about them. You might also investigate the reference and supplementary material in the classroom. Is there a file of art reproductions for use in class and for bulletin board display? If not, could you help develop one?

2. Note what audiovisual equipment is available in the room. Are there a slide collection, projectors, teaching machines, and record players? Several instructors may share this equipment. Find out how you can reserve it if you need to. Any teacher of the visual arts must not only become familiar with this equipment but should seek out ways of using it effectively in the art program.

3. Learn the location of all the art supplies and method of securing additional ones. You will probably find some school art supplies which are unfamiliar to you. Schools often use a "school grade" quality which is cheaper or safer for young people to use in the classroom than are some professional art materials you use in your own work. Budgets for art supplies are generally inadequate, so items must be carefully selected and maintained. Check the brand names. Why are some better than others for a particular situation? How are supplies ordered and from which suppliers? How are quantities determined? What are the specific sizes in brushes and paper? Where and how are these supplies stored — and why is this arrangement preferred over other possibilities? Are there supplies available which are not standard? Perhaps there are materials collected by the students themselves. Perhaps the art teacher has sought out materials from a special resource. You know, from your own experience, that many of the most challenging materials used in art are not on "supply lists," but are discovered by imaginative teachers from many unlikely sources. They

are often free or inexpensive and give an art program a special quality of its own. Finally, and most importantly, how are all these supplies distributed, cleaned, and collected in the classroom? And how do the procedures change with different classes and different lessons?

School and/or Classroom Regulations

1. Become familiar with the regulations under which you will work, such as the arrival and dismissal times for students and teaching staff. Learn about special assignments, including lunch room and playground duty, as well as extracurricular duties such as art clubs, yearbook, plays, and open house. Although you may not be asked to participate fully in these activities, the more involved you get, the more you'll learn.

2. Learn of any regulations concerning the behavior of your students and ways of dealing with rule infractions. How does your co-operating teacher handle these incidents? What do you think are the causes of some of these problems? How would you deal with the same situation—and why? Because of the diversity of materials and activities in the art room, certain rules are necessary for safety and infractions do occur. By watching an experienced teacher deal with these problems, you may be able to identify and even anticipate some of them.

3. Check on policy regarding homework and art materials which may be taken home. Students often ask to borrow art supplies or tools either to complete some class work or to do homework assignments, not only for art but for other subjects which use some art materials. Does your cooperating teacher give homework assignments? How much and what kind of work is useful for these students, considering their other subjects and the nature of your particular art program (art majors, art electives, art appreciation)?

4. Ask about the procedure to use in case of illness or injury to one of the students. Some art rooms have a small first-aid kit for minor cuts or burns, but other situations call for immediate professional help and a report to the administration and parent.

5. Become acquainted with regulations and procedures concerning taking students on class or group trips. Usually some kind of permission is necessary to just take the students outside the building. What trips are taken for other subject areas (English, social studies, science) which can be used for inspiration for art lessons? Collaboration with other teachers can enrich your art program. Is a visit to an art

museum or children's museum possible in your situation? At the high school level you may find it possible to take small groups (art club, art majors) to special places (sketching trip, exhibition, artist's studio) either during the school day or on Saturday.

6. Inquire as to any meetings your cooperating teacher is expected to attend (staff meetings, PTA) and see whether you might attend some of them. You will be interested in seeing how the interest of the art program can be forwarded by art teachers who take an active role in these meetings.

7. Observe the art teacher's methods of keeping reports, of reporting to parents, of taking attendance, and many other activities which are not directly related to the teaching of art but contribute to the total responsibility of any teacher in our schools today.

CONCLUSION

Whether you like or agree with all or any of what you see during this period of student teaching is considerably less important than what you understand about the things you observe. Perhaps the most important question you can ask yourself during and after observing a lesson is how would you improve the lesson. It would also be useful to make note of what aspect you would like to discuss in conference with your cooperating teacher and college supervisor. An open discussion of this kind can help you plan more effectively by utilizing the experience of other teachers to reinforce and develop your own teaching skills and understandings. In a later chapter, several ways of opening such a discussion with your cooperating teacher or supervisor are examined.

CHAPTER 5

Planning to Teach Art —
Theory into Action

Student teachers sometimes register surprise when they are asked to prepare lesson plans for the teaching of art. Perhaps there is something about observing an experienced art teacher conduct a lesson with great skill and ease in the classroom which might lead one to believe that this effortless performance was a purely spontaneous act, without preparation or planning. In most instances this is not the case. Often a master teacher's style is so deceptive (and yet effective) that it looks as if he or she has no plan. So, if your cooperating teacher seems to teach effectively without the complete kind of planning you are asked to do now, he probably does so because he already knows what his purposes are, the supplies he needs, and how he plans to proceed. Only actual experience can prepare you to eliminate some of the written planning necessary as a beginning teacher. Of course, as you continue to teach in the classroom, some aspects of planning will become second nature to you, and after a few years' experience, brief outline plans may be all the daily planning you will need. Detailed plans, however, are most necessary for the inexperienced teacher. These written plans are helpful because they compel you to organize your work and think through your problems. They may be referred to during class, thus keeping you to the main point of your lesson. They are also helpful in case there is a substitute teacher, because they give some idea as to the work already covered, and if new work cannot be done at least a good review may be had and thus the substitute service becomes more than mere police duty. Ultimately, your plans will determine your general and specific aims for learning and consequently the experiences available to your students.[1]

Perhaps the single most important advantage of a plan is that it is an instrument for thinking through an idea or topic utilizing several resources and procedures from beginning to culmination. A good plan

44

in art considers questions such as: What are the purposes or aims of the art activity; how can these be achieved most effectively; what materials, art supplies, instructional aids will be needed; what might you say, do, show, ask, etc., in order to help clarify your students' thinking and feeling about the subject, material, or ideas you have proposed? How can you motivate the class in general and yet stimulate individual and personal responses? How might you place great premium on exploration, invention, and discovery in the art room and still be confident that technical procedures and processes are clearly understood by your students?

A well organized plan also helps you gain security in your teaching by permitting you to concentrate on your students' reactions and the direction of their activities, rather than trying to organize subject matter content as an art activity progresses in the classroom.

As a student teacher, you will find that most principals, art supervisors, cooperating teachers, and college supervisors will expect you to plan thoroughly for your teaching. In fact, it is not unusual for full-fledged, experienced art teachers in our schools to be required to prepare and turn into the office written lesson plans regularly. These are examined by the school administration in order to keep them informed as to what is happening in the art room. Through your observations thus far, you may already have seen how important lesson planning is, and are beginning to recognize the fact that unless you plan, you cannot teach effectively over a period of time.

Finally, planning for the teaching of art is especially important because few art programs (with the exception of art history or appreciation) use class texts for art activities; therefore, the entire structure of a particular lesson or series of lessons depends largely upon you. Don't be surprised if most of your time is not being spent before the class teaching but, rather, in the planning stages before you even enter the art room. Also, don't be too hard on yourself or too disappointed if some of your early plans seem inadequate because of your lack of experience. You will, through continuous planning, gain the skills and knowledge necessary for good teaching.

TEACHER-PUPIL PLANNING

Many successful art teachers have learned that by including students in planning art activities the projects mean more to them and they tend to work with real concern for the success of the activity. This kind of planning also helps develop those habits of thinking necessary

for future individual and independent art activity. This preparation may vary from a simple introductory discussion to a day or two of planning for a major unit of work. The unit to be studied is often first determined by the teacher, in the broad sense, with students working within the limitations of the planned unit. This procedure is ideal for the teaching of art because it permits and encourages students to make extensive individual and personal decisions within broad subject matter or material areas. As a teacher of art, your knowledge of the needs of your students, their interests and their abilities, will help you guide them in the selection of activities and processes most helpful to their development.

There are often times when ideas for art activities and discussion will originate with the students themselves and you must be alert and flexible enough to capitalize on their spontaneous show of interest in your planning. Of course, it should be understood that your planning as a student teacher may indeed be different from planning if you were the art teacher. Many of you will be expected to work within the broad plans of your cooperating teacher.

You will probably find that there are not many art teaching situations which are so inflexible that they do not allow opportunity for some pupil-teacher planning. Most of the time it is less a question of curriculum restrictions and more a matter of your experience, flexibility, and interest.

TEACHER PLANNING

Since part of the art teacher's responsibility is to teach many skills and techniques in art during the year and to establish continuity in the work of his students, it may be necessary for him to plan the work logically so that problems develop sequentially and offer the students a balanced program in art. Here, again, the art guides or syllabus may well establish the framework within which the art teacher must plan.

These art guides, at both the elementary and secondary level, will not only help you cover the work expected by your cooperating teacher and college supervisor, but they will help familiarize you with your students' past experiences in art and enable you to plan for continual development. They often discuss the characteristics of students which are generally exhibited at different age levels. Being familiar with these will help you avoid a tendency to make plans which are beyond the capacity of your students. Of course, it is well to remember that these qualities are general and that people will vary both in the way they exhibit them as well as in the degree to which they have them.

The material you have available to you is another major factor in planning your art program. You should be flexible enough to modify your plans if certain materials are unavailable and resourceful enough to recognize what available materials would be useful to your program. Some of the most exciting and meaningful art projects have been planned with free or inexpensive materials which were readily available. Some art curricula will often determine how much freedom you will have for planning specific lessons. As far as possible, you are expected to adapt or adjust to the art program in your school. If and when strong conflicts arise between what your professional courses in art education have recommended and what you are asked to plan in your teaching situation, you should confer with your college supervisor at the earliest moment. Individual teaching situations often deviate from usual procedures when it is necessary. Because of your lack of experience you may not be aware of all the factors which affect a given situation. There may be important reasons why, for example, you might be asked to plan more "structured" lessons in art in a particular classroom or for a special group of students than might ordinarily be recommended. A discussion with your supervisor could help you understand the reasons for differences in both subject matter and method in a specific situation. He or she is also in the best position to discuss, explain, and reconcile some of the differences in philosophy between your cooperating teacher and your college.

A UNIT PLAN

A unit plan in art involves the teaching of a "unit" of work, usually requiring several processes and a number of studio sessions. Because related information, research, experimentation, and several processes are involved, several lesson plans are used in the construction of one unit plan. After completing your unit plan, a copy should be given to your cooperating teacher and to your college supervisor for their suggestions or approval. At this point you are ready to begin work on your daily lesson plans.

A LESSON PLAN

A lesson plan is a step-by-step, written account of what you would like to have happen during an art lesson. Some go further by including a self-evaluation which discusses what actually happened and why — and what steps are needed to improve the situation. This plan usually

deals with a simple problem that involved only one or two processes and can be completed by the students in one or two lessons.

In developing these outlines, you should ask yourself the following questions: *What* am I going to do in my art class today? *Why* do I want to do this for my students? *How* am I going to get them excited and enthusiastic about the idea and the materials? *What* materials and equipment do I need to get the lesson started and keep everything running smoothly? Both your cooperating teacher and your college supervisor will help you to put learning theory into action and to plan ways to build major concepts throughout your unit in your different kinds of teaching situations. Don't hesitate to ask for help when you are unsure. Close consultation in the beginning can help you avoid or at least lessen the impact of some planning problems in the future.

WHAT KIND OF PLAN IS BEST?

Colleges and art departments vary on the type of plan outlines they prefer students to use. However, most plans include some attention to: (a) statement of purpose (subject), (b) aims and objectives, (c) materials, supplies, and equipment, (d) motivation, (e) class evaluation, and (f) self-evaluation.

The lesson plan outline below is only one of several possible plans that you might use as a guide in your own situation. It contains many of the aspects useful in a written plan, but should be extended or modified, depending on your particular teaching needs.

1. Grade

 Identify the grade, section, and room numbers, name of teacher in charge of the class and the time of the art period.

2. Focus of the Lesson

 This could be a direct statement of what you hope to accomplish in the lesson. It might include a title of the lesson or theme, including unit title if necessary. For example, circus unit, lesson: (a) circus animals or (b) performers or (c) circus pictures or illustration.

3. Aims — Long-Range Goals

 Identify the part this activity plays in the art education of the student, such as: manipulative activity, the development of co-ordination and skills might be a long-range goal. Also, if related

to nature forms, a greater awareness, sensitivity, or appreciation would be another long-range goal. The long-range plans cannot be completed in merely one lesson.

Objectives — Immediate or Short-Range Goals

Immediate objectives or goals would include those dealing with this actual lesson and the time involved. For example: use of color in relation to the theme, composition, or use of space.

4. Materials, Supplies, and Equipment Needed to Be Sure That the Lesson Goes Smoothly

This might include everything for the accomplishment of the activity such as: water pans, thumbtacks, or tape, type of paint (water color or posters, etc.). Kind and size of paper, and brushes. All the materials needed for clean-up: paper towels, sponges, etc.; and any audiovisual material you plan to use.

5. Motivation

This could include a description of any means the teacher employs to interest the students in the art activity. This might include objects for inspiration, films, slides, stories, or costumes — with questions and comments that might be used.

There certainly seems to be a relationship between the quality of the motivation and the quality of interest and the art work that results. For example: Play record of circus music. Ask questions such as: "What part of the circus did you think of as you listened to the music?" "What else might you see?" These questions are used to stimulate discussion and to encourage visual images to each student. The motivation varies in length but should, as a rule, not be more than five to eight minutes in the elementary area and somewhat longer in the secondary school.

6. Class Evaluation

It is important that the art teacher provide leadership in getting pupils to evaluate the art activity, and to make suggestions for future growth of their own learning and appreciation. Here would be included leading questions and comments which might be used as starting points for a class evaluation or discussion. These should have a relationship to the motivation, aims, and objectives. The work of the entire class can be

displayed in a group on one side or in front of the room. If the work is three-dimensional the art work can be displayed on the desks, and the students can move around the room to look at each one carefully. The art teacher can ask questions such as: How does the color help tell the story or affect the mood of a work of art? By discussing what they did or might do in the future, the students will be evaluating their own work, as well as the works of their classmates. It is quite possible that the learnings and techniques acquired are not the same as those stated in your aims and objectives. By recognizing and capitalizing upon the new and spontaneous development, the teacher broadens the learning experience.

7. Sources and Resources

It would be useful to list here all sources of materials — reference and visual — which will help solve the art problem in any way. Books, articles, movies, slides, art reproductions, photographs, and records which are relative to the art project should be noted. Source of the material might well be included, such as community library, industry, retail shop, or personal collection.

8. Self-Evaluation

This might be a brief statement or analysis of each lesson after you have taught it. You could indicate what you had discovered, learned, or realized because of this experience. For example: Did you spend too much time on motivation so that there was not enough time left for completion of the art activity? Were the paint boxes in poor shape at the start of the lesson? Did you not insist on a quiet working atmosphere from the beginning, and did this permissiveness prevent the adequate completion of the work which in turn may have caused the students to be dissatisfied with their results? Did you notice that the record or costume you brought in for motivation contributed to student enthusiasm and quality art work? Were you flexible enough to adjust your plans when there was an opportunity to improve the learning situation?

You will soon realize that no matter how good a system is or how experienced the teacher, plans must sometimes change. If they never changed, it could mean that the teacher was insensitive to the class. All planning in art is to insure that the classroom experiences are at least as good as the plans. Naturally, if changes are called for they

should be in line with class interest, providing a better learning situation than would be possible with the initial scheme. In other words, the plan should not be your master — only your guide.

As soon as you assume responsibility for a class, you should be prepared to furnish written proposals to your cooperating teacher in advance in order to profit from his or her suggestions and help. Your college supervisor will be interested in the types of projects you are developing, too, and will generally offer suggestions concerning them. All outlines, however, that are to be used in the art room should be approved by your cooperating teacher.

SUMMARY

Your units and lessons in art will be effective if you consider the following basic factors in your planning:

1. Try to develop a clear idea of what you are going to do in the art class and why you want to do this for your students.

2. Art activities and studies should fit into the experiences, abilities, needs, and interest of the individuals in the class.

3. In order to insure a continuity of work, the annual or semester plan for a given grade should fit into an overall course of study. It also means that the units and the lessons within any given class will be interrelated.

4. Provide for group and individual differences in your planning.

5. Plans should be carefully organized to avoid wasting time.

6. Be flexible enough in your planning for emergencies or for change which will arise during the school year.

Although it should be understood that great plans in themselves do not automatically result in successful art lessons, they can help you reach your educational goals. They can also give you a great sense of security as you face your classes each day, as well as minimize your discipline difficulties while you put your theory into action.

CHAPTER 6

Discipline and Art Teaching

It is quite natural for you, as a student teacher, to be concerned about discipline. Almost all beginning art teachers are, and even some experienced ones find discipline to be one of their major problems at both the elementary and secondary levels. It would seem that you can be both enthusiastic about teaching and knowledgeable about your subject; but, if you can't control your class, you can't teach. It is important, therefore, that you use your student teaching experience to learn how to get and hold discipline in the art room. Unfortunately, there is no set of rules or regulations that will insure good discipline, because so much depends upon the particular situation and the characteristics of the individuals involved. On the other hand, there are some actions you can take to avoid some discipline problems, anticipate others, and resolve still other difficulties when they arise.

There are, of course, isolated behavior problems which arise that are unrelated to the kind of teaching going on in the classroom, but you should understand that poor teaching either in planning and organizing or in directing and evaluating is largely responsible for serious discipline problems in the art room. It is hoped that your cooperating teacher will discuss with you school policies relating to misbehavior and to treatment of discipline problems, and your authority and responsibility in this matter. If he doesn't initiate this discussion first, ask him. Everyone involved will benefit from a clear understanding of these policies. The suggestions on classroom management and on discipline in this chapter may be used as the basis for this discussion and could lead to some agreements and understandings.

As a student teacher, you should be aware of the fact that in some instances the very presence of your cooperating teacher in the room may have a positive and stabilizing effect on your students. Since he or she will not always be in your room, even during your student teaching, you should learn to take positive steps to maintain a good working atmosphere through your own efforts. To know which situation should

be handled by what method is, of course, a part of the "art" of teaching and only extensive observation, personal experience, and analysis can give you that knowledge. Until you acquire that kind of background, a firm but friendly and flexible attitude may be your best approach. Throughout your teaching career you will need to take various postures in the classroom ranging from authoritarian to democratic. Your attitude is probably the most important means of guiding the class you have. You can express, through it, your belief that art is an important subject and that you are committed to it. Your tone of voice, your confidence, and your show of interest and concern for your students all help to convey to your class that you anticipate their attention and their cooperation and that you expect to get it.

Someone once said that "art is fun" and much misunderstanding has occurred ever since. Art is not fun in the "Ha! Ha!" sense of the word. It is not "fun and games" time, nor is art time synonymous with recess. What was probably meant by "art is fun" was that learning about art and studio activities can give one deep satisfaction and pleasure. It's the kind of feeling you get when you have been completely involved physically, intellectually, and emotionally in any effort and feel that wonderful satisfaction of a job well done. You get that feeling when you play a good, hard game of tennis or chess, or from an evening of dancing, or even from a hearty round of group singing. In all of these activities you actually worked hard. You may have felt some frustration — even anxiety, but win, draw, or even lose, you experience the pleasure one gets from being committed and involved. Once you recognize this, you will be able to convey this attitude to your students by your whole presence and by a challenging but appropriate art program.

BEHAVIOR

Since behavior is the result of interrelated psychological factors, the more you know about human behavior the more sensitive you will become to the problems of classroom discipline.[1] Your courses in psychology, human development, and sociology have given you some theoretical background and this year your observations and student teaching will give you the opportunity to apply the theory to the practical problems involved in classroom discipline and control.

It may seem paradoxical, but art classes have the built-in potential for very few discipline problems, and at the same time, a great many opportunities for misbehavior.

Art activities should involve your students intellectually and emotionally as well as physically, absorbing them completely and deeply satisfying them personally and aesthetically. Through varied subject matter and the great range of processes and techniques, the needs of many diverse individuals can be met. This kind of total involvement leaves little room for idle talk or lack of interest.

On the other hand, this very diversity of supplies, equipment, and subject matter requires great individual freedom of choice and movement which can bring about frustration, noise, and confusion. Of course, problems in this area can be minimized greatly by simply routing equipment and supplies through several areas of distribution. In this way you avoid the crowding at one distribution point with its potential for confusion, noise, and accidents. Also, the process of learning skills and techniques for safe, responsible work habits requires patient concentration, hours of practice, and self-discipline.

The conditions outside the school also influence your students' behavior in the art room. Problems in the home, disadvantaged communities, low social and economic status, low mental maturity, and negative self-concepts all influence to some degree the behavior of your students.

There are even some "teacher caused" discipline problems brought about by the ineptness of the art teacher in both social and teaching skills. Such a teacher is often impolite or rude, inconsiderate of the feelings of others, too familiar with his students, or shows favoritism or discrimination.[2] It would seem that if you really go into class wanting to like and respect your students, it somehow gets across to them.

Group Atmosphere and Behavior

Research studies have supported the notion that the general classroom atmosphere does have great effect on the behavior, attitude, and learning process of students. Findings suggest that more effective learning experience seems to occur in a democratic atmosphere than in either a permissive or authoritarian one. Although these findings are limited to certain age groups and certain specific projects, they do indicate that there is greater group interacting, more ego-involvement, and more pride in the students' products in a democratic climate — that is, one in which the teacher offers guidance and help but permits many important decisions to be made by group discussion and group decision.[3]

On the other hand, the belief that true art expression is based on personal experience that is uniquely and individually the student's own, would imply the need for a permissive atmosphere characterized by complete freedom of individual decision.[4]

You will probably experience both of these climates in the art rooms you observe this year, along with a third type — authoritarian — in which all decisions are made by the teacher.

Each of these are valid at different times and under special circumstances in the art room. The atmosphere you create depends on your knowledge about the characteristics, previous experience, and influences of the members of your class, keeping in mind that, although some of your students may prefer and even work better in an authoritarian structure, autocratic rule does not help young people learn to stand on their own feet or make their own decisions. Current evidence seems to indicate that children who take over some responsibilities become ego-involved, more task-oriented, and consequently are less likely to misbehave.[5] Emphasizing democratic values and procedures in your art room will help you support and foster the goals of art education by establishing a stable, harmonious, and productive classroom atmosphere.

The kind of atmosphere you can create in the art room during your student teaching will depend to a great degree on the philosophy and approach of your cooperating teacher. It is possible, in most situations, with careful planning on your part, to interject a democratic atmosphere into the classroom when you teach, even if the regular teacher maintains a laissez-faire or authoritarian atmosphere generally. You can achieve this by planning activities which lend themselves to group discussion and decision-making. This can range anywhere from individual choice of subject matter or materials to group activities like mural-making or town-planning.

Other lessons may require limits to individual freedom or choice. For example, if you want the class to explore a specific characteristic of color such as value, it may be more effective to limit the problem to the use of one hue only, thereby encouraging the students to experiment in depth with shades and tints of one color. Even within a fairly restricted, teacher-determined lesson, you can give students decisions to make even if it is only selection of size and shape of paper, choice of medium or color, or interpretation of some facet of the subject matter.

It is both reasonable and even desirable to expect a limited amount of physical activity in the art room, since students should be

expected to participate in the distribution of materials and tools and also to share certain pieces of equipment. On the other hand, it is also sensible to recognize the fact that no one can create art work seriously while talking excessively or moving continuously around the room. Students, however, involved with interesting problems in art come to understand the need for a "working atmosphere" in the classroom. This self-discipline that they apply because they are interested and feel challenged is far superior to any form of external discipline a teacher could offer.

This "working atmosphere" should encourage your students to exchange views on their work with you and each other. You will recognize that certain kinds of activity demand certain kinds of noise (kneading of clay, construction, sculpture, etc.); but, within this framework, you must be willing to stop some minor transgression of conduct when it occurs and be alert to beginning or potential problems, such as inattention, irrelevant remarks, disproportionate laughing and talking.

Control Techniques in the Art Room. Some techniques strengthen students' self-control, others reduce their frustration, and some appeal to their understanding.[6] An effective art teacher senses which technique to use in which particular situation.

If you are teaching basically well behaved students, you might consider actions which will support your student's ability to control himself.

You could move closer to the noisy group to remind them of your presence. You might make a humorous comment or observation (no sarcasm) which would make its point, but not be threatening. You could boost their interest in or divert their attention back to their art work by commenting on it. There are even times when you might best ignore the noise for a moment if you think it will soon subside by itself.

There are other techniques you might try in order to reduce your students' frustrations by helping them reach their goals. Just after you have introduced and discussed the lesson and most of the class is busy working, you could quickly move about the room, stopping to help the student who did not quite understand some aspect of the lesson and therefore can't get started. A few words of explanation or even encouragement from you might be all he needs to move on toward finishing his work. If the whole class seems restless and unable to get down to work, you might choose to reintroduce the same concepts in a fresh or different way.

Watch individuals as they work. You might catch a technical error before the problem becomes major and discouraging. One person may

be using too much water; another not enough. A tool can be cutting too deep or the papier-mâché paste may be too thin. Little technical things can lead to frustration—and failure. Catch them in time and you develop confidence and skill and eventually success.

Students who finish their art assignments with amazing speed are sometimes people who are not very involved in their work. Their art work sometimes reveals insufficient conceptual and emotional elements or poor composition for the students' developmental level.[7] By your show of interest and skillful questioning you could challenge and encourage them to continue working on their projects. You help your students by encouraging them to recall what they already know but hadn't considered. You might even discuss or suggest several possible directions they could take.

There are, however, some young people who can work more quickly than others, and therefore you should plan activities which will keep these early finishers productively busy. A file of short projects related to the activity or supplementary to it could be offered.[8] This is especially effective at the elementary school level.

In the secondary school, the students could be given a choice of individual personal projects which could be started in class and continued on their free time at school or at home over the period of a semester. These ideas and others you may think of will help prevent disciplinary problems from developing in frustrated or bored youngsters. Since concentrated effort is essential in art, you should make every effort to motivate and give complete directions about procedure before the work period begins. Once the class is at work, move around the room, discussing each student's work individually. Of course, if there is a problem which seems to be widespread in the class, bring it to the attention of the whole group. Otherwise, deal with individual art work with helpful questions and comments—or sometimes just an encouraging look or nod of approval. Your continued presence and interest will encourage individual concentration and maintain the working climate of the class. Do not sit at your desk and become involved with other concerns while your class is in session. School records and reports should be worked on during your "free" periods or before or after class sessions. Administrators are increasingly providing "free time" during the school week for preparing lessons, ordering supplies, and keeping administrative records.

An art room that is a well organized, pleasant, safe, and functional place to work can also help maintain discipline. The room should be thoughtfully arranged so that students can clean up after themselves with relative ease. Supplies and equipment should be labeled and

working material should be kept in accessible places so that young-sters can get the materials they need quietly and quickly. Such an ar-rangement will also help you keep track of the tools and supplies dur-ing the semester.

Bulletin boards should be artistically arranged and changed often, so that students will be interested in looking at them and learning from then continually. Great interest is created when student work is frequently displayed. They would enjoy articles related to current art activities or special events, also. You, as a student teacher, have a unique opportunity, both while you observe and when you teach, to seek out the chance to put up some exciting visual displays. Class-room teachers as well as regular art teachers often neglect this way of creating interest in the art program. Your effort in this direction could re-inspire the regular teachers and encourage them to continue your example when they realize how effective it is. Some of the most excit-ing bulletin boards have been arranged by the students themselves. This is an excellent way to get them personally involved and an ef-fective method of applying their understanding of art principles to their environment and sharing these ideas with many students and teachers. You should encourage this kind of activity whenever possible.

The way the furniture is arranged in the room for art activities will affect the quality of the art work as well as influence student be-havior. Plan where in the room certain activities should be pursued. Large murals, for example, require large flat working areas. You may have to use the floor or the cafeteria tables, or even the hall corridor. Woodworking and clay activities should be separated physically, if possible, from areas of painting, drawing, and graphics. The nature of the art activity, the materials and tools used, and the size and maturity level of the class should all influence your room plan.

There are many times when an appeal to reason is both appropri-ate and effective in the art room. If you explain, for example, to even very young children, that paint brushes must be "patted" or "stroked" dry, not pulled by their bristles because the hair will come out (and not grow back in), they understand and try to remember.

Generally, if the reasons for proper care of supplies and equip-ment (so that they will be in good condition for use next time) are dis-cussed with students, they will respond positively and conscien-tiously. There are exceptions, of course, but these can be dealt with individually when problems occur. By assuming that you will get a positive and helpful response from your students, you encourage a positive class reaction.

While some of the above techniques will be useful to you during your beginning years of art teaching, you will probably find the two most consistently effective ways to capture the interest and enthusiasm of your students and minimize their misbehavior in the art room are (a) an exciting presentation of the art lesson—one which motivates and stimulates your students into full participation and (b) your own expertness—that is, a deep understanding and wide knowledge about the nature of art.

Negative Methods of Control. There are some methods of behavior control which even when seemingly effective should be avoided because they frequently do more harm than good. In some instances they eliminate the defiant behavior for a time, but may instead promote a negative attitude not only toward you, your subject, and the school, but toward the whole learning process. These negative methods include frequent detentions, sarcastic comments, forced apologies, personal indignities, and corporal punishment.

It would not be surprising if many of the adults today who "hate art" or feel uncomfortable or insecure doing creative art activities had been affected in school by negative and primitive methods of behavior control and have transferred this feeling years later to the whole area of art and other creative activities. Fortunately, in most schools today corporal punishment is against the law and rarely practiced. Other negative practices do continue to exist. Few of these frequently practiced by art teachers are the use of art or art history as a disciplinary measure and the sending of a student out of the art room where he will not be under supervision. These are both negative methods of control and should not be used.

A Positive Approach for Order. Your particular school may have a special procedure for dealing with the unusually disruptive student or emergency situations, but most of the time you are expected to handle the situation yourself. Research seems to suggest that asking a student to perform a proper behavior immediately following the wrong one may change behavior in the desired direction without producing the negative effects of punishment.[9]

This does not necessarily mean that punishment should never be used, but it does suggest that you should be aware of its many harmful side effects on the guilty student as well as on the class.[10]

The student who is well disciplined knows what he is supposed to do, how and when he is to do it, and goes about doing it in the proper manner. Some students get into trouble simply because they do not know what is right or they do not know what they are supposed to do.

Most students will need your sympathy and understanding as well as other help in arriving at the desired goal of self-discipline. You can help by having a constructive and positive attitude that assumes students want to learn, want to work, and want to do right. To accomplish this you may have to increase your own clarity and firmness in the art room. Studies[11] have reported over and over again that the students want a teacher who can not only explain lessons and assignments clearly, but one who is firm but fair, has control of the class, and therefore gains the respect of the class.

Classroom Management

The exact procedure you use in the art room is less important than the fact that you have a procedure and that you are fairly consistent in using it. In some situations you may find it best to use the system already established by your cooperating teacher. Over the years he has probably tried many approaches and has put into effect the one which seems to work best for him.

Some of you will no doubt be in classrooms without cooperating art teachers (self-contained situations or schools with art supervisors only) and will need to establish some procedures for efficient roll-taking, entering and leaving, distribution, cleaning up, and collection of supplies and equipment, and art work. The more cooperative this effort is, the more efficient the process will be, and the more time you will have with your major responsibility—teaching art. Those who are negligent or indifferent to this aspect of teaching find these mechanical details a constant source of confusion, which invites misbehavior and distraction, and takes valuable time and energy away from the art activity.

1. Class Movements

 a. Entering the art room

 The way students enter and leave the room often sets the tone of the whole period. If they enter quietly, settle down quickly, and get the materials they need right from the beginning, it will lessen the possibility of discipline problems and set a healthy pattern from the start. In the elementary area, you might stand at the door as the children come into the room. Your presence will often quiet them down even before they get into your room, and a look or gesture from you can set the pattern for a quiet beginning. At the secondary

level you may want to establish a studio atmosphere where your students go right to work on their previous project as soon as they have entered the art room. This method probably works best in an art major situation, where the students are strongly self-motivated, involved with individual projects using a variety of media and equipment, and are comparatively few in number. For general art classes at the secondary level it might be well for you to stand at your desk, wait for the students to come in and settle down before you begin. If you do this consistently, your students will come to expect it, and will usually respond positively, knowing that you won't start until the room is settled.

b. Movements within the room

Experienced art teachers generally adopt a permissive atmosphere toward students leaving their seats to ask questions, get supplies, or to look at the work of classmates. You could ask your students to raise their hands when they need help and you can then come and speak to each individually wherever he is working. If the question deals with the project at hand, the art work would be right there for both student and you to discuss. You may have to learn not to answer the student who consistently disregards this requirement. Gradually, you might permit more freedom of movement when possible, so that your students can learn to accept and handle more responsibility.

c. Leaving the art room

How you dismiss a class and how the students leave the room can affect the general atmosphere of the class also. Since you will be using a variety of art materials in your classes, it is important that you give your students enough time to wash brushes, clean paint boxes, and put other supplies and equipment in their places and clean the room up in general. It might be useful to announce to the class that they have five or so minutes to finish what they're working on before it's time to clean up. In that way they can bring their work to a conclusion up to that point and will not start anything new. They can complete a particular drawing, or use up a mixed color and generally adjust themselves to the idea that they are going to stop work very shortly.

In elementary situations in particular, you will find the children so absorbed in the activity that they continue to work long after you have asked the class to stop and clean up. You may have to take a firm stand on this point, by having the primary tool or material collected immediately after your stop signal. You can reduce their temptation to rush their work before the materials are collected by assuring them of an opportunity to continue their work at a later time (recess, after school, after completion of other work, etc.).

After all the material and equipment have been cleaned and put into their proper places, the class is ready for dismissal — by you, not the bell. They should all be in their seats quietly waiting for you to give them the signal to leave. Since no one wants to be late for his next class (including yourself), you should avoid that possibility by deliberately planning enough time at the end of a session for an orderly withdrawal.

2. Distribution and Collection of Supplies and Equipment

At both the elementary and secondary levels, students should be included in the scheme of classroom management. Most students are eager to help their teachers even in what may seem to you to be menial tasks like distribution and collection of materials, equipment, and art work as well as keeping the supplies in good condition and in general classroom housekeeping. Don't ask for volunteers. Select helpers who you feel can do the job required, quickly, efficiently, and quietly. Give a number of different students a chance to help (but only two or three at a time) and create the feeling that you have confidence in their ability to do a good job. Helpers, to be of real value, should be briefed on their work. By discussion with the class, standards of performance can be developed. If students feel that assisting you is a privilege (one which can and should be taken away if not done with serious effort), they will usually try to come up to your expectations in order to hold on to their task or to have another chance at it. Sometimes even the aggressive or hostile student who generally seems uncooperative becomes a force for good when given special attention and responsibility in this way. While supplies and equipment are being distributed by your helpers, you should stand aside and see to it that all goes well, making suggestions and comments as needed. In other words, you supervise this process while still holding the attention of the rest of the class.

3. Language and Speech

Directions and motivations are wasted when given to an in-attentive class, so first make certain everyone is looking at you and listening to you whenever you talk to the whole group. Then give directions — step by step, if need be — making sure each is understood before going on to the next. Use as many sensory channels as possible to reinforce your verbal explanations. These might be a demonstration, a finished product, a film, or just the use of the chalkboard. If students begin talking, you stop and wait until you have the attention of everyone again, including those in the back of the room. Speak slowly and calmly, and try to keep pitch of voice low, but watch to see if those in the back can hear you. Sometimes moving around the room while you speak and addressing the class from different places in the room (not always in front of the room) helps students focus their attention on you and what you are saying.

Be sure to adjust the speed of your speech and choice of vocabulary to the maturity level and background of your students. Just about every subject area has its own professional jargon, and art is no exception. There are technical names, trade names of media and equipment, extensive abstract and historical terminology which have meaning only to experienced artists. You should, of course, use the proper names for the tools and media you use in class but take the time to write the unfamiliar words on the board and discuss them on a level which your students will understand. It won't be long before you find that even the most abstract or complicated concepts can be discussed with children and young people at their maturity level. Ask the class questions to see if they understand the concepts expressed as well as your directions. Through group discussion you can find out if they really understood your words and their relevance to the lesson. In many situations you may have to explain the same idea in several different ways to reach the understanding of all your students.

If you use a friendly conversational tone when talking to your classes, you may avoid a common pitfall of some art teachers — that is, excessive lecturing. This is as important in the secondary school as it is with young children. Most people enjoy being talked to rather than lectured, and there is certainly less chance for you being "tuned out" by your audience. The informal nature of art itself is conducive to this approach and can be an effective means of reaching your art goals.

There are, of course, certain sections of the art curriculum (art history) and types of classes (general art appreciation) that lend themselves to the lecture technique—especially at the secondary level. These can be especially interesting and effective if they are not only well prepared, but if you also reinforce your words by using a variety of techniques and approaches such as movies, slides, overhead and opaque projectors, guest speakers, field trips, exhibitions, and, when possible, related small discussion groups.

SUMMARY

How to get and maintain a productive working atmosphere in the art room:

1. Classroom Management

 a. Distribution of supplies

 Try to pass back some supplies.
 Try to have only a few helpers with supplies.
 Do not ask for helpers—choose two or three.
 Explain that those chosen must *help*—work carefully and quietly—if necessary, choose others.
 Ask students to put name and sections or grades neatly at bottom of paper while supplies are being given out (on the side they paint on so you can learn their names).
 Have a regular system of giving out and cleaning up.

 b. Motivation

 Speak slowly and calmly.
 Try to keep pitch of voice low but watch to see if those in the back can hear you.
 Do not begin until the room is quiet and each person is looking at you.
 Do not use the expression "I should like you to do," etc. Instead, motivate by telling a story, painting a word picture, bringing in some interesting object, or ask questions about an experience.
 Ask questions, then get them to tell you more with paint— or whatever the material.
 Motivation or approach should be simple and direct, yet should be the type that really makes students want to express their ideas.

c. Climate and support for a productive art program

Room should have a "working atmosphere."
Do not spend much time with one student to the exclusion of others—often just a quiet word is needed.
Watch individuals as they *work*; they may need some technical help which you could provide.
Watch for the student who seems to be at a loss; just a question may help.
If room becomes noisy, it often helps to stop work entirely—brushes down, etc., "We need to think as we paint and to work quietly so we will not disturb others."
Watch for misuse of the material—paint, clay, etc.—perhaps your class has not understood something you said at the beginning.
Encourage sincerely—not just a "blanket praise" that has no meaning.

d. Concluding the lesson

Give class advance notice of stopping time so that they have an opportunity to work toward a reasonable stopping point. Assure them of a future chance to complete the work without rushing.
Clean up in logical order: papers and brushes first, then water, then pans, etc.
One helper can collect papers from two rows at once—another can help you put the papers up on wall for evaluation and discussion.

2. Teacher-Student Relations

a. Avoid making threats or issuing orders that can cause pupils to challenge you; do not pick a fight.

b. Be ready to give the student the benefit of the doubt; remember you could be wrong and the student could be right.

c. Do not make a big production out of something that is trivial.

d. Be consistent; do not change the rules without good reason.

e. Isolate the offender or offenders; send to the office only as a last resort.

f. Do not punish the entire class for one or a few offenders.

g. Do not ridicule or embarrass the student.

h. Give yourself a chance to think before you administer punishment; a cooling-off period may change things.

i. Do not hold a grudge, but get it over with and start with a fresh, wholesome point of view.

j. In serious cases, be certain to include not only the cooperating teacher but the principal also, in administering punishment.

All art teachers, at one time or another, have discipline problems. As student teachers, you will be expected to have them also. It is hoped that your cooperating teacher will not over-protect you from the necessary experience of recognizing the cause and effect of behavior problems and the opportunity to confront them and resolve them. The more experience you have now, the better prepared you will be for your first year on your own.

It is recognized that some of the problems you encounter will not be caused by your action. It is important, however, that you soon learn that your attitudes and purposes and the classroom conditions you create can modify student behavior. Some of the suggestions in this chapter may help. On the other hand, many may not apply to your particular situation and you will have to devise others. You may be completely on your own in a rural situation which has only an art supervisor who visits you occasionally, or you may be in a large school system with a cooperating teacher, guidance counselors, and other professionals to help you. No one expects you to eliminate behavior problems, but your cooperating teacher and college supervisor do expect you to recognize them and take action to encourage productive behavior. Experienced and sensitive art teachers have recognized for years that a stimulating, flexible art program guided by a well prepared art teacher, who loves to work with children and youth, is the surest and ultimately most effective way of minimizing behavior problems in the art room.

CHAPTER 7

You and Your Supervisors

Fortunately, you are not expected to go through this experience of student teaching entirely on your own, without a great deal of guidance and help. Your cooperating or training teachers and college supervisors have been carefully selected to provide the encouragement, opportunities, and guidance you may need from the moment you step into your classroom to your final student teaching seminar.

YOU AND YOUR COOPERATING TEACHER

There seems to be broad general agreement among teachers of art and, in fact, student teachers themselves, that the cooperating teacher probably plays the most important role in your student teaching experience. Studies have shown that he or she is probably the most influential factor in determining the kind of teaching you will do once you assume a teaching position of your own.[1] He is, after all, closest to you and your work in the art room day after day, hour after hour, and therefore becomes the greatest single force shaping your professional development. It is natural, therefore, that the quality of your student teaching experience and the extent to which you will benefit from this experience depends a great deal upon the relationship you develop and maintain with him.[2] Your cooperating teacher can demonstrate to you in a practical way not only the challenge that teaching will present and the responsibility you must assume, but also the pleasure and satisfaction you can gain through successful art teaching. Most of you will find this relationship a mutually satisfying one. On the other hand, some of you may find student teaching less satisfying than it should be because you or your cooperating teacher or both of you do not understand each other, or one resents or dominates the other, or one or both of you feel certain pressures resulting from the close association. However, the more you know about him

and the complex nature of his role and responsibility, the more understanding you will be able to bring to this situation and perhaps contribute in a positive way toward developing a friendly and helpful working relationship.

WHO IS YOUR COOPERATING TEACHER?

Cooperating teachers (sometimes called critic, supervising, or master teachers) are selected by various criteria. Most colleges seek teachers who have demonstrated their ability to teach art effectively in the classroom and have a positive attitude toward teaching and toward working with student teachers. At the elementary level your cooperating teacher may be the art supervisor of the school district, or the art teacher — if they have one — or even a classroom teacher who, although not an art specialist, has demonstrated the elements of good teaching and the ability to analyze basic principles of teaching and learning in a self-contained classroom. You may even work with several teachers in one school or several schools. At the secondary level your cooperating teacher may be the chairman of the art department or one of several art teachers in the school. Here, again, it is not unusual to be assigned to two cooperating teachers, so that you can have a broader experience, particularly in specialized areas such as art history, art major programs, vocational art, and other specialized programs.

There are usually a number of different reasons why a particular cooperating teacher accepts the responsibility of guiding a student teacher. They can range all the way from being pressured by his administrative supervisor or wanting someone to do his work for him, to feeling a professional obligation or pleasure in the challenging new role of cooperating teacher. Others may even accept for the small token compensation some colleges pay (often in the form of a two- or three-point tuition exemption for classes taken at the college), although this small remuneration is hardly sufficient to pay for all the extra knowledge, skills, and work which are required. Naturally, colleges try to avoid assigning student teachers to those teachers whose motivation is less than professional.[3] Most colleges continue to search for those teachers who have a commitment to the profession and a real desire to improve it.

Whatever his motivation, however, by accepting a student teacher, the cooperating teacher commits himself to give the necessary time and energy needed to insure a maximum learning opportunity.

Although, admittedly, the educational background of these teachers can still vary widely today, the trend in the past few years for art teachers has been upgraded. Many now include a broad general knowledge plus an almost professional knowledge in one studio area of specialization.[4] You can be reasonably confident that your college does try to secure the best qualified teachers available.

RESPONSIBILITIES OF THE COOPERATING TEACHER

Orientation

From the very beginning he can help you feel a part of the school to which you have been assigned by introducing you to as many of the personnel as possible and, most importantly, to his classes as a colleague. He may acquaint you with some of the facilities you will be able to use during your student teaching such as the library and audiovisual department. He will explain your schedules and inform you of the extra duties expected, if any. He will show you around the art rooms, especially the supply closet, and discuss the method used for requisitioning art materials. He may even invite you to attend faculty meetings, art clubs, open house, or other special events which will occur during your stay.

Guiding You in Discipline

Since a working atmosphere is essential in the art room, your cooperating teacher will help you acquire the skills of group control. Through his own enthusiasm, self-control, and mastery of his subject, you will be able to observe several methods of controlling groups of varying ability and behavior. He will help you understand the various needs, interests, and abilities of your students, so that you can attain the discipline expected.

Guiding You in Planning

Although planning is largely your responsibility, your cooperating teacher can be of great help, especially in the beginning. He can discuss your plans with you. He might alert you to the difficulties that may arise in the learning process that he can foresee and even suggest effective approaches to meet these problems. He can also help you present your material in such a way that you will get the maximum attention and understanding of your students.

Guiding You in the Understanding of Your Students

In order that you get to know and understand your students, your cooperating teacher may acquaint you with student records from the guidance office or health services. Special and confidential information of this type can broaden your understanding of particular situations and help you deal more effectively with your students as individuals. Naturally, it is important to treat all confidential material clinically.

Guiding You in Acquiring Teaching Techniques

Your cooperating teacher is committed to give you as much freedom and responsibility as possible. However, he or she will probably permit you to take on only such responsibility in teaching as you prove yourself capable of doing. For the first two weeks, you might work with individuals or groups or assist in many other ways while your cooperating teacher observes the way that you work with your classes. You might take over the entire class for portions of a period until gradually you are able to assume full responsibility for each of your classes for an extended period of time. It is part of the cooperating teacher's responsibility to encourage you to try out your own plans and procedures, but you must recognize, however, his first obligation is to the students in his classes whom he is employed to teach, and therefore no class should suffer through poor management and inadequate preparation in subject matter or in the lessons to be presented. Your cooperating teacher can, from his wide experience, refer to sources such as curriculum guides, visual aids, instructional material, and books which will broaden your background and understanding, thereby helping you to become a more effective art teacher.

Acquainting You with Necessary Routines in the Art Room

Art classes, like all other classes, have mechanical procedures which fulfill particular requirements and help the class to function smoothly. Your cooperating teacher is best qualified to introduce these to you. They involve housekeeping activities, fire drills, home-room procedures, passes and detentions, and the overall policy of the school on such as homework, parent interviews, and special reports. Watch him carefully. Feel free to ask questions of him at a time that seems convenient to him.

Evaluation

You can expect your cooperating teacher to continually evaluate you and your actions, both in the art room and out of regular classroom

hours as long as you are in this situation. By helping you plan and by observing you teach, he is more able to guide you in the evaluation of your own strengths and weaknesses. It is hoped that he will be quick to point out your successės and emphasize your strengths, as well as be frank in pointing out to you ways in which any phase of your work may be improved. He will most likely arrange for regular private conferences with you. Some of these may also include your college supervisor.

Your cooperating teacher will not only evaluate your teaching and you, but will also help you with individual evaluations of your students' growth in art, and of final art projects. Ultimately he has the responsibility to evaluate the quality of your whole performance as an art teacher. This may call for a summary evaluation in cooperation with your college supervisor. Since this written evaluation or recommendation of the master teacher is one which is given most weight by superintendents and hiring committees, every attempt is made to be as accurate and fair as possible.

YOU AND YOUR COLLEGE SUPERVISOR

Each of you will also have, throughout your student teaching experience, the guidance of a college supervisor. They are sometimes known as off-campus supervisors, resident supervisors, or clinical teachers. Whatever their title, their main educational purpose is the same — that is, to help you teach art successfully.

Schools now recognize that the professor from the college or university who is to supervise and assess the practice teaching should be a professional with a great deal of practical experience and are now making every effort to employ people with this qualification.[5] You may be fortunate enough to have as your university or college supervisor an artist-teacher member of your art department, especially one of your methods teachers.[6] In recent years, schools with art education departments have made a special effort to have student teachers of art supervised by members of their staffs whenever possible. Often these people have had extensive art teaching experience in our public schools and are selected to be supervisors by the college because of their outstanding record as art teachers. Many have also had extensive and special graduate work in the area of art education as part of their background.

Some college and university art departments rotate the assignment of supervision of student teaching among their art teaching faculty, giving everyone in the department an opportunity to work with

student teachers out in the schools as well as with students in their own studio classes at the university. This enables the student teacher to meet most of the college art staff and gives the fine arts oriented teachers in the department greater insight into the needs and problems of teaching art in the public schools.

Still other schools select their supervisors from the office of student teaching. These are usually experienced teachers, with a rich professional background in the field of education and a strong interest in student teaching.

ROLE OF THE COLLEGE SUPERVISOR

The director of student teaching or a member of the art education department is usually responsible for the administration of the student teaching program in art. During the student teaching period, your college supervisor acts as liaison officer between the college or university and the cooperating school. Part of his responsibility is to explain your college and art department policies concerning student teaching to administrators, teachers, and staff of your cooperating school.

He or she will often discuss with your cooperating teacher your educational background, college commitments, and other pertinent information about you. He will no doubt brief you concerning your responsibilities both to the college and to your own cooperating school. In one way or another, he will talk to you about the community, the educational philosophy of the administration of your school, and other special information which would be useful to know about your assigned classes.

It is one of his major responsibilities to confer with your cooperating teacher about your progress and try to help the cooperating teacher help you. In order to do this, he will visit you and observe your teaching of art from about three to six times during the student teaching period. He will often ask to meet with you not only in individual conferences, but with your cooperating teacher in three-way conferences to discuss your progress and problems. Finally, he will evaluate your progress in the light of his personal observations and conferences with your cooperating teacher, department chairman, art supervisor, and school administrators.

As a student teacher, you should make as much use of your college supervisor as you can. He is, after all, in the best position to have a broad, overall view of the entire situation. He knows the administration and the educational philosophy of your school. He is aware of

their special problems and needs, including their budget situation and their system for ordering supplies and equipment. He may have played a role in selecting your cooperating teacher and will often know about his educational background and experience. He will certainly be familiar with the art curriculum of the school system as well as the state guides in art education. He may even have taken part in their development. All of these factors have a major influence on the direction of the art program in your school.

You would be wise to discuss your problems and conflicts as they arise with your supervisor—before they become major problems with unfortunate consequences. If, for example, your cooperating teacher is not willing to surrender to you the responsibility for his class or does not permit you to teach often enough, or on a regular basis even after several weeks of observation, you should discuss this problem with your college supervisor so that he can use his influence in your behalf. Perhaps your cooperating teacher may feel that you have not demonstrated enough interest, confidence, or planning skills to take over his class. On the other hand, he may feel threatened by your presence or insecure in his own teaching. Your college supervisor may have to persuade him to share some of his authority with you.[7]

Philosophical conflicts of method may also arise and require help from your college supervisor. Another of his responsibilities is helping you to understand the relationship between theory and practice. Most of the conflicts in this area can be settled on a thoughtful, cooperative basis if he is aware of them in the beginning so he can act quickly and decisively. But, your college supervisor is not a mind reader or a miracle worker, so do not expect his understanding if you have made no attempt to keep him informed along the way. He expects problems to arise during student teaching and he is anxious to help you. However, his visits to your classes are comparatively few, and it is not possible for him to be aware of everything that is disturbing you unless you tell him about it. A conference may be all that is needed to help the situation. If more action is called for, he is prepared to take the necessary steps. Whatever action is taken, you can usually count on his understanding and discreetness.

It is natural, perhaps, that both you and your cooperating teacher may be a bit apprehensive about a visit from the college supervisor. There have been cases where special preparations were made for the visit. Since it may not be possible to have a "teacher as usual" situation if a college supervisor's visit is known in advance, some art supervisors just "drop in" unannounced to see the regular class activities. Of course, they know your teaching schedule and are familiar with

your plans, so they may have come to see either a general situation or a specific lesson. If you are in the process of teaching at the time of a visit, you should find an opportune time to introduce your college supervisor to your class as a "guest or an art teacher who has come to visit." Since some of you may not have a cooperating art teacher in the room at the time of this visit, you could suggest that "this visitor or art teacher would be glad to help while he's here." This would allow the supervisor to help you if needed, without undermining your authority.

After the college supervisor establishes a friendly, helpful rapport with your classes, the students often look forward to his subsequent visits as an old friend interested in their progress in art. Introducing your supervisor to your class should be the only unusual action you should take. Teach the lesson and conduct the class as you had planned. The supervisor can help you the most by seeing a real-life situation with you going about your job as usual, rather than putting on a special performance for him. Most supervisors are experienced enough to sense the reality of the situation anyhow, and you'll find it less of a strain just being yourself and concentrating your attention on the art lesson and the class.

Try to arrange a conference shortly after his visit, so that his comments and suggestions will be fresh in your mind. Remember that no single observation is of critical importance. Your supervisor is interested in your overall growth and improvement. Naturally, he would like to see some of his suggestions put into action when possible. However, he does not expect a "perfect" situation but is more interested in your capacity to learn from past errors and your willingness to explore new solutions in a variety of situations. He is very much aware of the possible tension or strain on you and the cooperating teacher caused by his visits and will usually make every effort to create a helpful interaction in order to achieve the best art program possible. The relationship between you, the cooperative teacher, and the supervisor has to be the cordial, mutually respectful relationship of workers concerned with the achievement of common purpose, if it is to be completely successful. There are so many variable factors that this relationship is not easily achieved. However, if you recognize your supervisor as someone who is there primarily to help you succeed rather than merely someone to evaluate your work, you will be able to develop a positive attitude toward his visits and to make full use of his background and experience.

SUMMARY

We have only briefly discussed the cooperating teacher and how he or she can help you. Since you will be looking to him for guidance, approval, help, sympathy, ideas, and criticism, and since you know he is going to play such an important part in shaping your professional career, it is of critical importance that you work hard to develop that friendly, helpful working relationship mentioned earlier in this chapter. Get to know him as a person. What standards does he have? What goals does he have for his classes? Just what does he expect of you? By finding out what he is like as a person, you are letting him know what you are like, also. Naturally, you will want to maintain a professional relationship, but one that is mutually understanding and cooperative. Ideally, your cooperating teacher should be a master teacher with extensive experience and great skill. However, if he is less than "ideal" remember that it is possible for you to learn a great deal from a situation that is not "perfect" or even one that is negative. The value of this experience depends largely on your own understanding and perception.

Most of you will find that your cooperating teacher, whether he is an art specialist or classroom teacher, is committed to help you. Use his help. Seek his advice and guidance. He will be pleased that you do, and you and your students will gain from his interest and understanding.

The same holds true for your college supervisor. He will do his best to help both you and your training teacher work well together. He has carefully considered your placement in that particular situation, and is anxious to see you succeed in it. If your college supervisor is an art specialist, you can expect him to become more directly involved in actually planning with you, because he is more familiar with the field of art and with specific approaches to teaching art. In other words, he is able to assume a consultant role with the cooperating teacher. On the other hand, if your college supervisor is a general supervisor, with expertise in education and student teaching, he will be most concerned with the overall guidance of your student teaching experience, including the planning of the types of experiences in which you should participate, leaving the specialized role of art expert to the cooperating teacher. In either case, you can count on your college supervisor planning to confer with you about your work and to suggest possible solutions to some of the problems you have encountered.

Both supervisors, the cooperating teacher and college supervisor,

are primarily interested in the growth and development of students and in your success as a teacher. Nothing less than a real team effort is required for your maximum development as an art teacher.

CHAPTER 8

You and Evaluation

Evaluation is a continuous and cooperative process which begins with the first day of your student teaching assignment and becomes an integral part of your whole program. It involves not only you but your students, your cooperating teacher, the school administrators, and your college supervisor. Its major function is to help you recognize and utilize your personal and professional strengths in teaching competence and to help you identify and overcome your weaknesses.

As a student teacher of art you will be largely concerned with three important but different aspects of evaluation: (1) self-evaluation, (2) evaluation of you and your teaching by your cooperating teacher and your college supervisor, and (3) your evaluation of the creative efforts of your students and of their learning in the art class.

SELF-EVALUATION

Since an important goal of evaluation in student teaching is to help you bring about desired behavioral change, it's most critical that you develop a sensitivity as to what constitutes good art teaching, and to become really aware of your own strengths and weaknesses. Of course, you can't overcome your shortcomings unless you recognize that they exist. When things are not going well in the art class, too many teachers ask the question "What is wrong with this group?" instead of starting with the question "What is wrong with me?"[1] Once you are ready to face up to yourself and to discover your weaknesses in order to improve, you are ready for self-evaluation. However, those of you who continue to blame your difficulties on others are not ready for self-appraisal, for it is essential that you admit your errors and need for improvement before self-evaluation can be of any help to you.[2]

One of the most widely used instruments for self-evaluation is a check list. It usually considers items concerning your personal

qualities as an individual, your professional preparation and knowledge, and your actual teaching performance. The best check list you could use would be one which you developed through discussion with your cooperating teacher and your college supervisor, using your own set of criteria. In that way you establish a cooperative scale which would have specific relevance to your particular teaching situation. This is, unfortunately, not always possible, so you may have to examine other rating scales and choose one which you can adopt and adapt for your use.

One method of self-evaluation, called "A Guide for Teacher Self-Analysis," was devised by a group of teachers attempting to identify those characteristics that seemed to make superior teachers. The scale was an outgrowth of their study of "superior teachers" and was designed for teachers who were interested in analyzing their own strengths and weaknesses. Part of this check list is included here because it may be helpful to you in pinpointing the major areas of concern for self-appraisal which are relevant to your student teaching in art—especially in the elementary school.

A Guide for Teacher Self-Analysis[3]

In living and working with pupils . . .

Do I show an interest in pupils as persons —

Study and use pupil records?
Take time to converse with pupils about personal interests and ambitions?
Look for reasons back of irregular attendance and poor health?
Give children an opportunity to convey their feelings—in compositions, inventories, creative dramatics?

Do I adhere to the principle that rights and rules apply equally to all —

Refrain from "riding" or directing sarcasm at the non-conformer?
Avoid assuming that the "good" pupil is always "good"?
Apply and make exceptions to rules with equal consideration to all pupils?

Do I provide direction and security without dominating pupils —

Give pupils opportunity to help set up the rules by which they live and work?
Help pupils understand the necessity for a classroom atmosphere

conducive to work?
Practice the democracy I preach?

Do I communicate with pupils on their level of understanding—

Try to find out pupils' likes and dislikes as a guide for communicating with them?
Use a variety of communication media in search of "the best way" for each pupil?

Do I plan and evaluate as much work as possible with pupils—

Allot time and guide each pupil in evaluating his work in terms of his ability and ambitions?
Distinguish between decisions and directions better made by me and those that pupils can and should help make?
Mean it when I say "let's plan," or is my mind made up as to what the class will do?

Do I individualize instruction—

Use a wide variety of instructional materials?
Suggest a variety of activities from which children can choose according to interest and need?
Give the pupils a chance to work in small groups which they volunteer for?
Assign work that is challenging and based upon pupils' interests and capacities?

Do I try new and different techniques and routines—

Observe and adapt routines and good practices that colleagues use?
Make a distinction between long- and short-term goals?

Do I stimulate pupils to think, evaluate information, and substantiate conclusions—

Say "I don't know, let's find out" without hesitation when pupils ask questions I can't answer?

It is, of course, quite possible that your college has developed a set of criteria which are used by your cooperating teacher and your college supervisor to evaluate your work. In that case, it would be a good idea for you to consider some of these criteria in your self-evaluation. In that way you can rate yourself for comparison with the rating of your supervisors and draw attention to areas not commented upon.

This singles out to both you and your supervisors the specific area where particular attention needs to be given.

The ultimate function of a check list or rating scale is to draw your attention to qualities and procedures which could strengthen and support your effectiveness in the art room. You, however, will bring to your situation personal and unique strengths which never appear on evaluation guides or rating scales. The characteristics you bring to your teaching simply because you are who you are can make the difference in the quality of the education your students will enjoy. By being yourself, you instinctively use your special strengths and bring to your teaching a quality that is uniquely your own.

STUDENT TEACHER EVALUATION BY THE COOPERATING TEACHER AND THE COLLEGE SUPERVISOR

Both your cooperating teacher and college supervisor are charged with the responsibility of continually appraising your progress throughout your student teaching assignment. They do this in several ways, including the reading of your lesson plans, observing you with your students and colleagues in and outside of class, observing your teaching, reading your reports, and through conferences with you, the school staff and administration, and each other. Of the various techniques used by supervisors to evaluate student teacher progress, the two most frequently used are (1) written evaluations in conjunction with check lists and (2) in-person, two- and three-way conferences directly related to your teaching. This second technique is especially helpful because an open discussion between you and your evaluators can minimize misunderstandings and misinterpretation of their suggestions.[4]

While the first and most important reason for these evaluations is to help you become a more effective art teacher, they also have two other functions. One is to provide your college with information regarding the strengths and weaknesses of its art education program. The other is to provide evaluative information to be included in your placement folders or set of credentials sent to employing officers. Since these evaluations may become a part of your permanent records, you'll want to be sure they reflect your best effort.

Because student teaching is so complex, the practice of "grading" student teachers has been substituted in some colleges by a grade of pass-fail only. Still other institutions which continue to use the traditional A, B, C scale of grading are careful to reserve the "A" rating

for only the most outstanding student teachers, the "B" grade for those who do excellent work and are above average in potential, and the "C" rating for student teachers who do adequate work in the classroom. Any grade below that of "C" is often not considered a satisfactory rating; those student teachers may not be recommended for teacher certification.

In most situations, you will find that your college supervisor is the person responsible for your summary grade or evaluation. He will, of course, take into account the evaluations of your cooperating teacher and others in your school, but he alone remains charged with the responsibility of recording your final grade in student teaching.

EVALUATION OF YOUR STUDENTS' EXPERIENCES

Evaluating the creative efforts of your students and of their learning in art should be, like the evaluation of your own student teaching, an integral part of the whole learning situation and a continual process. This requires at least three major considerations: (1) evaluating successive stages of a work of art and the procedures involved in accomplishing these stages; (2) evaluating the aesthetic value of the finished product; and (3) evaluating pupil growth through the experiences undergone during the planning and work on the product.[5]

Too often inexperienced art teachers consider only the final product in their evaluation of their students' development, either ignoring or not realizing that the meaning of the final product as an expression of creativity can be fully understood only as it is seen in relation to the total development of the child.[6] This calls for more than just achievement in skills; it requires evaluation of aesthetic responses, of creative approaches to solving problems of space, form, and color,[7] and of knowledge about art produced in our culture and in others, both past and contemporary.

Last, but perhaps most important of all, is your evaluation of your students' ability to appraise the results of their involvement in art activities in a way that will promote their capacity to be constructively critical of their own work. Research into the relative effectiveness of art evaluation has suggested that the student himself is the most qualified person to make meaningful assessments of his progress and should therefore be given the tools and opportunity to evaluate his own development. To be most effective, this process of student self-evaluation must be a continual one, beginning in the earliest stages of the art activity, occurring often during the activity itself, as well as at

the end. Unless you can determine the progress your students are making, you have little way of knowing how effective you are as a teacher, and chances are you will not be very efficient in guiding their further development and learning.

In both the elementary and the secondary schools, most art teachers agree that there can be no fixed standards of achievement for all children at any one grade level, since young people vary in their potentialities, develop at different rates, and differ in so many aspects of their experiences. In the elementary area there is broad acceptance as one basis for evaluation, the general expectancies for various levels of maturity in the areas of mental, social, emotional, physical, and creative growth which have been developed by such authorities as Gesell, Olson, Jersild, Lowenfeld, and Schaefer-Simmern. You have probably already discussed the work of these men in your child development and art education courses, and realize they offer general flexible standards to guide you in your evaluations, but not rigid rules to follow blindly.

At both levels, an important basis for evaluation of art experiences is evidence of growth. Growth is considered satisfactory when your students exhibit behavior that shows the continued or increasing presence of:

1. Confidence in ability to express oneself visually.
2. Interest in expressing ideas and feelings in visual form.
3. Awareness of the environment and power of observation.
4. Power to interpret everyday experiences.
5. Inventiveness in the areas of ideas and materials.
6. Ease and satisfaction in using a variety of tools and materials.
7. Understanding and appreciation of the contributions of other peoples.
8. Ability to work in a problem situation.
9. Individuality in expression and appreciation of individuality in the work of others.
10. Power to produce unity and give meaning through the organization of line, form, color, and texture.[8]

Some of you may be asked to deal with only one or two aspects of evaluation, while others may be responsible for a single grade to be recorded as your student's grade in art. The former is more likely to occur when teaching art in the secondary school, while the latter may be necessary at the elementary school level where you may be the only art specialist.

If you are asked to "grade" your students' art work and progress, most of you will want to be as objective as possible in arriving at marks. Marking is not easy for any teacher, but it is especially complex and vexing for teachers of art. Many art educators today believe that grading should not occur in the field of art. They argue that (1) grading children's art products often creates anxieties which can hamper creative expression and make the child feel both insecure and threatened; (2) because art is a unique expression of a unique individual, it is a personal thing and therefore cannot be compared or evaluated; (3) when teachers grade art work, they tend to concern themselves with the product and not the process; (4) art preferences are a matter of taste and one cannot justify one's likes or dislikes; and (5) often adult evaluations have little meaning or relevance to the child.

On the other hand, those who endorse evaluation and grading as a valid procedure in art teaching offer arguments that are equally persuasive. They believe that (1) the school would be ignorant of the effectiveness of the art program in reaching its educational goals without evaluation; (2) there would be little evidence to support curricular changes and innovation; (3) no instruction would be possible except for the teaching of mere technical skills and procedures which reduces the role of the art teacher to that of a "supply sergeant" and relinquishes the art teachers' claim to any artistic expertise; (4) students of all ages want and need honest criticism to provide a sense of direction and framework of security; and (5) an effective art teacher can and will apply criteria that are relevant and meaningful to young people.[9]

The argument is further complicated by those who believe that evaluation in art is necessary and vital for effective teaching, but that evaluation need not culminate in a "grade." Not only they, but most art educators, find it inconceivable that a letter or numeral expressed in percentages could ever represent an adequate picture of the status of a student—or the growth he has made.

What then is a fair—and accurate—way to evaluate students in art? Without doubt the written statement that indicates as specifically as possible the status of the student in behavior and accomplishment and makes recommendations for further direction is the most satisfactory type of report that can be used in the art room. It is obvious that this method imposes a burden on the art teacher—especially those with large and diverse classes—but its results seem to warrant the effort put into it.[10] You can collect evaluative evidence for this kind of report through informal and formal conversations with your students, keeping careful records to help you recall certain behavior, and

through individual folders containing work your students have selected to keep during the semester.

Many elementary schools have already adopted this method of grading. Some other schools use the traditional grading system of A, B, C for all subject areas except art, music, and physical education.

Although the issues and arguments involved in evaluation and grading are far from settled, the fact remains that the "mark" is still regarded as an objective by most students and most of our schools continue to use the traditional methods of grading. The reasons usually given for the continuance of grades being awarded on the traditional basis are (1) education as a whole is still subject-matter centered; (2) parents are still insistent on knowing what their children are achieving in a subject; (3) institutions of higher education still largely insist on grades as objective evidence for admission.[11]

Even these reasons seem less valid today than they were years ago. Change and innovation in education are occurring at a rapid pace. Students, parents, and educators are increasingly becoming more interested in anecdotal reports and personal conferences supported by records than in merely a numerical rating or grade. This trend is an encouraging sign for those who teach in the arts because it means that evaluation can be based on consideration of the student's total experience and can be stated and regarded as data for future direction of both the student and teacher.

SUMMARY

You are in the special situation of being evaluated by your cooperating teacher, your college supervisor, and even school administrators, while at the same time you are evaluating your own effectiveness as a teacher, as well as your students' progress in art. In each instance, the process of evaluation will be most valuable if it is both a cooperative effort and a continual one. The techniques of evaluation include a check list used as a basis for conferences and self-analysis; observation reports, anecdotal reports, individual and group conferences, and the traditional methods of letter or numerical grade. You may encounter all or only some of these techniques in your particular situation. Remember each has its advantages and limitations and some are more effective than others under different circumstances. More important than which technique is used for evaluation is the realization that proper assessment of your growth as a student teacher is absolutely essential if you are to improve your personal and professional competencies.

CHAPTER 9

You and the Profession

As you get to know the teachers and supervisors you will be working with during your student teaching, you will probably discover that some of them are active members in one or more professional associations — and for good reasons. They have found that one way to keep abreast of their field and to learn about the thinking of other art teachers and specialists has been to associate themselves with an organized group of people with the common interest of art education. Many have also discovered that they can express their own views on educational matters and even influence the actions of administrators, parents, and government. By uniting with others and speaking with one powerful voice through their associations, they become an effective instrument for change and progress. Through the years, art teachers have found that professional associations can significantly stimulate improvement in the quality of instruction and the environment in which instruction takes place.[1]

NATIONAL ORGANIZATIONS

The National Education Association (NEA), the largest and most influential professional group for teachers in this country, has expressed in a recent position paper the direction that their organization is now taking.

Beginning now we are going to put our power and influence to work for the things that are really the most important. NEA will:

Be unrelenting in seeking a better economic break for teachers in this affluent society;
Become a political power second to no other special interest group;
Insist that the profession at all levels have a voice in the formulation of educational policy, in curriculum change, and in educational planning;

Have more and more to say about how a teacher is educated;

Stop the old argument within its ranks over welfare versus educational leadership; and, finally, NEA will organize this profession from top to bottom into logical operational units that can move swiftly and effectively and with power unmatched by any other organized group in the nation.[2]

By furthering the cause of education in general, the NEA is improving teaching standards in all fields as well as advancing the lot of all teachers at every level.

One of the departments of the NEA, the National Art Education Association (NAEA), should have special relevance to you and your work, for it is made up of the membership of four Regional Art Association affiliates — Eastern, Pacific, Southeastern, and Western. Although this department is comparatively young, having been established in its present form in 1947, it has made great strides in establishing a posture of leadership for improving the quality of art instruction throughout the United States. Through its biennial conferences, yearbook, special studies, and monthly journal, *Art Education*, attention is focused on problems and concerns in art education on the national and even international scene. It is largely through these activities and extensive publications that art teachers and supervisors are not only kept informed about innovations in art curriculum, techniques, and materials, but also have the opportunity to contribute their ideas and research to a large and interested group of other art professionals. A recent example of an NAEA publication is called *Exemplary Programs in Art Education*. This is a 128-page book, given free to members, containing detailed descriptions of thirty-nine exemplary programs in art education across the United States.[3] Other publication titles include *Studies in Art Education, Art for the Academically Talented Student in Secondary School, Art Education in the Elementary School, Art Education in the Junior High School, Art Education in the Senior High School,* and *Art Education for the Disadvantaged Child.*

The NAEA Convention, which is held biennially in different parts of the country, is an exciting experience. Here art teachers have a wonderful opportunity to catch up on the latest information in their field; to see new and improved materials and techniques introduced and demonstrated; to see new films on art; to see, hear, and meet outstanding people not only in art education but in many related fields as well. By attending their sessions, you will begin to see your co-workers not only as competent professionals, but as warm, friendly individuals. To many of you, a convention of this scale will provide the opportunity to enjoy the cultural offerings of a large, unfamiliar metropolitan area.

A useful feature of the convention is a job placement service. This has proven to be very successful in helping art teachers who are looking for positions to meet employers looking for art teachers. This service could prove especially helpful to those who will be available and looking for your first position upon completion of your student teaching.

REGIONAL ASSOCIATIONS

Although the four regional art associations are affiliates of the National Art Education Association, they are independently very active. Each publishes a monthly bulletin which includes discussions of all phases of art and art education along with book reviews, calendar of events, and exciting visual material. These regional groups hold biennial conventions also. These are similar in most respects to the national convention except in scale. They provide conferences, meetings, exhibitions, films, workshops, and other opportunities for professional and social get-togethers. Fortunately, you are eligible to join your regional association at a substantially reduced student rate, which gives you all the privileges of full membership—publications, conferences, literature, etc.—except the right to vote for officers of the organization. By joining your regional association you automatically become a member of the NAEA.

STATE GROUPS

Most of the states in the United States have some type of art education group at the state level. At times these groups are actually a part of the state teachers' association, while in other places the art education group is independent. In either case, you will find their publications and meetings both interesting and helpful to you as an art teacher. They frequently discuss issues and personalities of local concern and support special events and exhibitions for area teachers. A strong local association can also bring to the attention of state representatives and legislators many of the programs in art which need state approval and support.

INTERNATIONAL ORGANIZATIONS

One significant step forward in behalf of international art education was made in 1954 when the International Society for Education

Through Art (INSEA) was founded. Distinguished artists, writers, and art educators, including Professor Edwin Ziegfeld from the United States and Sir Herbert Read from England, have worked diligently and successfully to make this organization an effective voice of the international community.

The World Congress of the INSEA met for the first time in the United States in 1969 and a large number of American art educators had the opportunity to meet and hear art teachers from widely differing geographical and cultural areas. The theme for the congress was "Education Through Art: Humanism in a Technological Age." Past meetings of INSEA have been held in Prague, Paris, Tokyo, The Hague, Manila, and Montreal. Membership in the INSEA should appeal to all of you who are seriously interested in education through art and believe that international conferences can be of great educational and cultural significance.[4]

TEACHERS' UNIONS

There has been a dramatic increase in the growth of teachers' unions. They range from small local independent unions to those associated with the large national groups such as AFL-CIO. All unions, regardless of size or type, are formed to improve the employment conditions of member teachers, and are usually concerned with pay, promotion, tenure, sick leave, and general working conditions. Although these issues are not of major concern to you as a student teacher — or even as a beginning teacher — they may gain in importance as you establish yourself in the profession. Professional organizations and teachers' unions have many goals in common, although the means each employs to reach these goals may differ sharply. In both cases, however, it is the collective voice of teachers which brings about reform and progress.

ADVANCED STUDY

After your first few weeks of student teaching it is not unusual for you to become painfully aware that you still have a lot to learn. Some of you have had a substantial education in the arts — others only a bare minimum. Some may find that, although you have had extensive experience in one phase of art (painting, graphics, etc.), you are woefully lacking in knowledge of, and experience with, the practical arts and

crafts, or art history, or aesthetics. Still others will find that they have a broad background in the arts but cannot work in depth in any one of them. Undertaking formal graduate study is one way you can continue to grow professionally and give your career the balance, direction, and reinforcement that were not possible at the undergraduate level. Advanced work at the university is increasingly a part of your commitment to education, and most schools encourage if not require teachers to work on a master's degree after they have been teaching a year or two. Today, more than at any time in the recent past, there is a concentration on discussing and knowing about art, and it is necessary, therefore, that you become competent in art criticism, art history and appreciation, as well as in art production.[5]

Graduate courses in art are many and varied and can be taken at night and during summers while you continue to teach on a full-time basis. Some of you may decide to go right into graduate work full-time after receiving your bachelor's degree. This has the advantage of a continuous, uninterrupted, and concentrated period of study, on one hand, but lacks the balance provided by practical experience and insight gained from a year or two out in the field. The direction you take should depend on your special interests and talents, and should be discussed with your college advisers and members of the art department. Although most administrators are eager to employ teachers with advanced degree work, many prefer candidates with some proven experience and skills in art teaching. The level of your salary in a teaching situation often depends on the number of years' experience you have as well as the number of graduate credits you have earned. These factors also affect your eligibility for state certification. Many beginning art teachers find that they have a better basis for planning their future direction after their first year of full-time teaching. Some then consider taking advanced work in art supervision and other specialized areas of art teaching and administration.

ART PRODUCTION

Another aspect of professional growth, and a critical one for art teachers, is your continued creative growth as an artist. You will be expected not only to teach children and assist the classroom teacher who must concern himself with more than one subject, but also to be skilled in at least one productive aspect of art. The sureness and conviction that comes from personal accomplishment will help you teach persuasively and effectively. This kind of skill comes from hard work

and prolonged association with a few media.[6] Today more and more teachers of art are as strongly concerned with their own art as they are intensely interested in their teaching. These teachers recognize the fact that personal studio practice and instruction in art can proceed hand in hand.[7] To be an artist you must work at it—not occasionally, but regularly. Your first year of art teaching may take more of your time and energy than you had planned; but if you work out some sort of schedule, including weekends and summer vacation, you will find that you can continue to develop as an artist while you teach. In fact, you may well discover what other artist-teachers have found, that each activity reinforces and complements the other.

PROFESSIONAL WRITING

As an art teacher you have splendid opportunity—even obligation —to share your ideas, including successful programs, projects, research and criticism on art and art education, with other members of your profession. Periodicals such as *Art Education, School Arts, Arts and Activities,* and regional and local art education bulletins are receptive to informative articles on all aspects of art teaching. You make an important contribution to the whole profession when you discuss relevant issues, or introduce new materials and techniques, or report on recent research. Descriptions and photographs of what you are doing in your art room could inform and inspire countless art teachers throughout the country. Aside from the personal satisfaction you will get from your writing and the contribution it will make, your school and students will be pleased and proud of your accomplishment and your efforts will not go unnoticed by your administrators.

SUMMARY

You have probably gathered by now that being a member of a profession like art teaching involves many facets. Four major aspects include (1) membership and active participation in art education associations, (2) graduate study, (3) personal art production, and (4) professional writing. All of these add up to your professional growth. Your active involvement in each of these will help you gain both personal satisfaction and professional status, while at the same time you help art education programs become more important and more effective in our schools today—and in the future.

CHAPTER 10

Your First Teaching Position

Most of you are now doing your student teaching during or close to your senior year of undergraduate work. During this time it's natural that you will be looking forward to, and planning for, your first teaching position as an art teacher.

COLLEGE PLACEMENT BUREAU

The first step in acquiring a position is usually handled by the placement office at your college. In this case, you first complete forms stating some personal information (such as address, age, sex, and marital status) and preferences of teaching levels (elementary, junior high, senior high) and/or specialized studio or vocational areas in which you are skilled and interested in teaching; furthermore, you may be asked to give your geographic preferences and the type of school (public or private) you would prefer most. In almost all instances, several references are usually required. Your complete file is kept at the office to be sent to a school system or administrator to whom you are applying for a position. References are important and may stay with your records for years; therefore you would be well advised to request references of those persons who are in a position to give you a very favorable recommendation. It is always good practice to ask people for permission to use their names as references before you submit the names to the placement bureau. The list of references could—and in fact should, whenever possible—include teachers and supervisors under whom you have done your student teaching, members of your college faculty who know your creative ability, and former employers who can speak well of your ability and industry in other fields (summer programs, day camps, part-time positions). It can also be valuable to include some references from people who can attest to your qualities (community and religious leaders, professional and family friends

who have known you personally for a good period of time). All of these credentials are confidential and sent out only upon your request or the request of the prospective employer. When positions in art become available, the placement office will notify you. In the event that the administrator plans to interview at your college, the office will schedule the appointment; otherwise, you must make the necessary arrangements. If the latter is the case, you must write a letter of application to the person or persons mentioned in the notice you received from the placement agency. It is, of course, most important that you promptly acknowledge all correspondence pertaining to your employment negotiations; but, if a school does wish to interview you, don't accept unless you are sincerely interested.

LETTER OF APPLICATION

While it is probably true that your ability to write a good letter of application is not the most valid criterion upon which to judge your art teaching ability, you should recognize a simple fact of life: that is, an administrator will have a reaction to your letter and will gain his first impression of you from it. It is to your benefit that this impression be as good as you can make it. You can be reasonably sure that an inquiry stating your interest in a position, identifying briefly your training and experience through a neat, correct, and business-like letter will create the most favorable impression of you and may well bring a positive response from the administrator.[1]

One effective idea is to include, along with a short letter of inquiry, a data sheet or resumé which states pertinent information in a concise, easy-to-read, outline form. This should include personal data, educational preparation, teaching experience, other work experience, awards and scholarships, special interests and skills, military service, travel, and list of references — professional and personal, with complete addresses.

Your letter of inquiry should emphasize your interest in teaching art to young people and not your interest in salary schedules, security, ease of assignment, and length of school day. There will be ample time in subsequent correspondence or interviews to discuss these and other aspects of the position.

PREPARE FOR THE INTERVIEW

You can do several things to prepare yourself for an effective interview. Inquire about some background information concerning the

school you are applying to. Prepare a portfolio representing your successful achievements in your work at the college. You could have a series of slides (and viewer) to show examples of your own work and that of your students made during your student teaching. Dress thoughtfully, being carefully groomed and reasonable in the style of clothes you choose. Administrators tend to put more stress on these aspects than artists do. First impressions, however, can sometimes be lasting ones; so make yours one of someone who has been considerate of all aspects of the situation. Finally, be on time (even a little ahead) for your appointment.

THE INTERVIEW

The administrator conducting the interview will usually take the lead in doing most of the talking and questioning. It's up to you to answer his questions as fully and concisely as you can, keeping in mind he is as interested in the way you express yourself as much as in the answers themselves.

Administrators are generally enthusiastic about candidates who are interested enough to ask pertinent questions about curriculum, facilities, responsibilities, and school policies. Questions that could be asked in these areas are:

1. Curriculum

 a. What role does art play in the total curriculum?
 b. How recently has the curriculum been revised?
 c. How much art is given to elementary students?
 d. Do you give art regents or tests?
 e. How many students select art as an elective in high school?
 f. What other related subjects is the art teacher expected to teach?

2. Facilities

 a. What is the allotment per student in the art budget?
 b. Do the elementary schools have a special art room?
 c. What community resources are available for the art teaching?

3. Responsibilities

 a. What would some of my other duties and responsibilities be?
 b. What time does school begin and what is a reasonable time for the teachers to remain after dismissal?

4. School Policies

 a. Are there art workshops and extension courses offered by the school?
 b. Is there a merit system?
 c. What is the policy on sick leave?
 d. What about pensions and insurance?
 e. What is the salary schedule range?
 f. What about increments?
 g. Are teachers paid every two weeks or once a month?
 h. Is salary extended over a period of ten months or a year?
 i. What is the turnover of teachers in the school system?

Of course, some of these questions and others may be answered for you without your asking during the course of conversation. Finally, the administrator will close the interview—usually with assurances that the school will contact you one way or another concerning the position, by a particular time. When this date comes, and if you are offered the position—and still want it—contact the superintendent and give him your answer. When your contract arrives, read it carefully, sign it, and return it promptly. If you have further questions about the position or contract, ask them before you return the signed contract. Your contract or letter of employment should state clearly both the amount and payment of salary and your teaching assignment.

Once you have committed yourself to a situation, notify the placement office of your decision.

COMMERCIAL PLACEMENT AGENCIES

Commercial placement agencies, which are located throughout the country, operate not only in local or regional areas, but nationally and internationally as well. This is a special advantage to those teachers who want a position in a distant area of the country and overseas. These agencies are also quite successful in locating positions in private and public schools which your college might not know about. Most private agencies ask for 5 percent of your first year's salary as a fee for locating a position for you, and you can usually arrange to make this payment over a period of time during your first year of teaching. Although some employers do prefer to find teachers through private agencies, most seem to favor college placement bureaus. There are, however, some teachers who have found commercial agencies helpful

in locating available positions at the last minute or during mid-semester or under special circumstances.

OTHER SOURCES

There is no question that placement agencies, whether public, private, commercial, or college affiliated, can save you countless hours of searching out a position for yourself. There are, however, other means available to you also.

You may be fortunate enough to be asked to stay on in the school in which you are doing your student teaching. Naturally, this would depend on particular circumstances. Your school may want you to stay on, and need you very much, but cannot at that moment afford to take on new faculty, or may need someone with extensive experience. If you are asked to stay on, and do so, it is certainly a great compliment to you.

Some schools advertise in the press when there are teacher vacancies available. Leading newspapers and some professional journals regularly carry a listing of position vacancies and of teachers looking for positions. This approach is not too promising for art teachers except those interested in private schools. Many large metropolitan papers have a similar service, but the listings are few and highly competitive.

Frequently, members of your art department know about positions available. Heads of departments often get requests for teachers through friends and colleagues in the profession. You would do well to keep in touch with your department and let your professors know that you are looking for a position.[2]

Finally, you can resort to a "do-it-yourself campaign." That is, decide where you would like to teach art and set about to see various principals and art superintendents with the hope of locating a position. This is "doing it the hard way," but it has "paid off" for some art teachers who want a specific situation and have the industry and ability to get it.

The distribution of supply and demand for art teachers today nationwide is "near balance." This has been the general condition of art education since 1968. On one hand, this is certainly good news, because it means that art education programs are becoming increasingly more important in public education.[3] On the other hand, it may suggest that you will have a more difficult time securing a position as art teacher than art education graduates did several years back when the

demand was greater than the supply. School administrators have always looked for the best teacher available, but now they will have a choice. They can select—not settle. This means that you must work harder to secure a position—and to keep it.

SUMMARY

It should be encouraging for you to know that there are a number of ways you can seek out the right art teaching position for you. No matter which approach you use (college placement, commercial agency, letters of inquiry, or newspaper advertisements), recognize the importance of your initial letter of application and your interview. In both of these, emphasize your positive assets without distorting the truth. If art teaching is to be your life's work, seek out the position which you feel is all-around best for you. The salary may not be as high as you'd like, or the working conditions may not be the best; but other factors may compensate, such as the opportunity to grow as a teacher, freedom to explore and innovate in your teaching, and receptive, understanding co-workers.

Consider your first teaching situation as a place you would like to stay for a few years—perhaps not forever, but long enough to do a good job and make a real contribution. If you establish a strong reputation as an excellent artist-teacher during your first few years in the field, you will find that many opportunities for the future will be open to you.

A Last Word

Much has been said in this book about teacher, teaching, and art education. Some of what has been discussed may be helpful to you as you begin your student teaching. Other facets may be more useful to you once you have been in your cooperating school for a little while. A few of the questions you may have had about student teaching in art may have been answered, while others remain to be answered by you after some experience in the art room.

This discussion of ideas and suggestions about art teaching is only a prelude to a great adventure. There are few people who can do more than you to nurture human behavior based on respect for others as individuals. Although the methods you use in teaching art will always be an individual matter, guided by your personal philosophy and particular art strengths, your guidance, stimulation, and inspiration will encourage each individual student to develop to the maximum of his own potential. No art teacher could ask for more!

Notes

INTRODUCTION

1. "Who's in Charge Here?" Discussion paper, National Commission on Teacher Education and Professional Standards (National Education Association, 1966).

2. John Benz, *The Essentials of a Quality School Art Program: A Position Statement* (Washington, D.C.: National Art Education Association, 1968).

3. Arthur D. Efland, "Educating Tomorrow's Art Teacher," *Art Education*, 20, No. 8 (November 1967), 14.

4. Ivan Johnson, "The Basis for Art Teacher Preparation," in *Report of the Commission on Art Education*, Jerome J. Hausman, ed. (Washington, D.C.: National Art Education Association, 1965), p. 121.

CHAPTER 1

1. Harold A. Schultz, "The Teacher of Art," in *Report of the Commission on Art Education*, Jerome J. Hausman, ed. (Washington, D.C.: National Art Education Association, 1965), p. 108.

2. Earl W. Linderman, "Dialogue for Good Teaching," *Art Education*, 20, No. 7 (October 1967), 22.

3. Ivan Johnson, "The Basis for Art Teacher Preparation," in *Report of the Commission on Art Education*, Jerome J. Hausman, ed. (Washington, D.C.: National Art Education Association, 1965), p. 124.

CHAPTER 2

1. *Identifying Superior Teachers*, A report of a study by Central School Boards Committee for Educational Research (Institute of Administrative Research, 1959), p. 5.

2. Irving Kaufman, *Art and Education in Contemporary Culture* (New York: The Macmillan Company, 1966), p. 13.

3. Ibid.

4. Harold A. Schultz, "The Teacher of Art," in *Report of the Commission on Art Education*, Jerome J. Hausman, ed. (Washington, D.C.: National Art Education Association, 1965), p. 116.

5. Ibid.

6. "Key Concepts from Discussion Groups Responding to Major Speeches at the Pacific Regional Convention," *Art Education*, 21, No. 6 (June 1968), 26.

7. James A. Schenneller, *Art/Search and Self-Discovery* (Scranton, Penn.: International Textbook Company, 1961), p. 16.

8. Betty Lark-Horovitz, Hilda Lewis, and Mark Luca, *Understanding Children's Art for Better Teaching* (Columbus, Ohio: Charles E. Merrill, 1967), p. 5.

9. Abraham H. Maslow, *Toward a Psychology of Being* (Princeton, N.J.: D. Van Nostrand, 1962), p. 130.

10. Earl W. Linderman, "Dialogue for Good Teaching," *Art Education*, 20, No. 7 (October 1967), 22.

11. John H. Fischer, Speech at Fifteenth Annual Meeting of American Association of Colleges for Teacher Education (Chicago, Ill.).

CHAPTER 3

1. Thomas Woody, ed., *Educational Views of Benjamin Franklin* (New York: McGraw-Hill Book Co., 1934), p. 27.

2. Walter Smith, *Art Education, Scholastic and Industrial* (Boston: Osgood & Co., 1872), p. v.

3. "As an Art Teacher I Believe That," *Art Education*, 2, No. 2 (March-April 1949), 1.

4. John Benz, *The Essentials of a Quality School Art Program: A Position Statement* (Washington, D.C.: National Art Education Association, 1968).

5. Arthur W. Foshay, "Changing Goals and Art Education," Conference on Curriculum and Instruction Development in Art Education: A Project Report, Alice A. D. Baumgarner, Director (National Art Education, 1967), p. 31.

6. Walter Gropius, "Letter to the Editor," *Playboy*, 16, No. 5 (May 1969), 10.

7. Research Monography 1963-M, *Music and Art in the Public Schools* (National Education Association, August 1963).

8. Edwin Ziegfeld, *The Current Scene: Problems and Prospects for Art Education Today*, Report of the Commission on Art Education, Jerome S. Hausman, ed. (Washington, D.C.: National Art Education Association 1965), p. 1.

9. *Why Art Education?* Brochure, Publication Division of National Education Association, Association Stock No. 051-02096.

10. Justin Schorr, "Aesthetic Education for a Change," *Art Education*, 20, No. 9 (December 1967), 43.

11. Benz, op. cit.

12. Susanne K. Langer, "The Cultural Importance of the Art," in *Aesthetic Form and Education*, Michael L. Andrews, ed. (Syracuse, N.Y.: Syracuse University Press, 1958), p. 6.

13. Benz, op. cit.

14. Irving Kaufman, *Art and Education in Contemporary Culture* (New York: The Macmillan Company, 1966), p. 50.

15. Benz, op. cit.

16. Howard Conant and Arne Randall, *Art in Education* (Peoria, Ill.: Charles A. Bennett Co., 1959), p. 177.

17. Hilda Present Lewis, *Art Education in the Elementary School* (Washington, D.C.: American Educational Research Association, 1961), p. 5.

18. Gertrude Howell Hildreth, *Educating the Gifted Child at Hunter College* (New York: Harper & Brothers, 1952), p. 187.

19. Betty Lark-Horovitz, Hilda Lewis, and Mark Luca, *Understanding Children's Art for Better Teaching* (Columbus, Ohio: Charles E. Merrill, 1967), pp. 134-41.

20. T. B. Munro, Betty Lark-Horovitz, and E. N. Barnhart, "Children's Art Abilities: Studies at the Cleveland Museum of Art," *Journal of Experimental Education*, 11, No. 2 (1942), 97-155.

21. Edwin Ziegfeld, *National Education Association Project on the Academically Talented Student* (Washington, D.C.: National Education Association, 1961), p. 14.

22. Malinda Garton, *Teaching the Educable Mentally Retarded* (Springfield, Ill.: Charles C. Thomas, 1964), p. 183.

23. Lark-Horovitz, Lewis, and Luca, op. cit., p. 143.

24. Charles D. and Margaret R. Gaitskell, *Art Education for the Slow Learner* (Peoria, Ill.: Charles A. Bennett Co., 1953).

25. Ray Page, "Education and the Visual Arts," *Illinois Journal of Education* (September 1965), p. 44.

26. Dorothy Westby-Gibson, "New Perspectives for Art Education: Teaching the Disadvantaged," *Art Education*, 21, No. 8 (1968), 22.

27. J. S. Bruner, "The Cognitive Consequences of Early Sensory Deprivation," in *Sensory Deprivation*, P. Soloman, ed. (Cambridge, Mass.: Harvard University Press, 1961).

28. Barbara Biber, "Educational Needs of Young Deprived Children," *Childhood Education*, 44 (September 1967), 34.

29. Bernard I. Forman, "Accent on Africa," *Art Education* (November 1968), pp. 30-35.

30. Westby-Gibson, loc. cit.

31. June King McFee, "Art for the Economically and Socially Deprived," *The Sixty-Fourth Yearbook of the National Society for the Study of Education* (Chicago: National Society for the Study of Education, 1965).

CHAPTER 5

1. Helen M. Diemert, "Class: Where Theory Becomes Practice," *Art Education*, 22, No. 3 (March 1969), 9.

CHAPTER 6

1. Rolf E. Muuss, *First Aid for Classroom Discipline Problems* (New York: Holt, Rinehart & Winston, 1962), p. iii.

2. Wellington B. Grey, *Student Teaching in Art* (Scranton, Penn.: International Textbook Co., 1960), pp. 63-64.

3. Muuss, op. cit., p. 40.

4. Mark Luca and Robert Ken, *Art Education: Strategies of Teaching* (Englewood Cliffs, N.J.: Prentice-Hall, 1968).

5. Muuss, op. cit., p. 48.

6. William J. Gnagey, "Controlling Classroom Misbehavior—What Research Says to the Teacher," *Art Education* (1965), pp. 7-9.

7. Kenneth M. Lansing, *Art, Artists, and Art Education* (New York: McGraw-Hill Book Co., 1969), p. 380.

8. Ibid.

9. Muuss, op. cit., p. 6.

10. Gnagey, loc. cit.

11. William M. Alexander, *Are You a Good Teacher?* (New York: Holt, Rinehart & Winston, 1960), pp. 17-19.

CHAPTER 7

1. William A. Bennie, *Cooperation for Better Student Teaching* (Minneapolis: Burgess Publishing Co., 1967), p. 35.

2. Alex F. Perrodin, *The Student Teacher's Reader: Developing as a Professional Worker* (Chicago: Rand McNally & Co., 1966), p. 41.

3. Bennie, op. cit., pp. 35-36.

4. John Diffily, "Course Requirements for Prospective Teachers of Art, 1941-1962," *Studies in Art Education*, 4, No. 2 (Spring 1963), 57.

5. James B. Conant, *The Education of American Teachers* (New York: McGraw-Hill Book Co., 1963), p. 143.

6. Perrodin, op. cit., p. 18.

7. Thomas J. Brown, *Student Teaching in a Secondary School* (New York: Harper & Row, 1960), pp. 127-28.

CHAPTER 8

1. William A. Bennie, *Cooperation for Better Student Teaching* (Minneapolis: Burgess Publishing Co., 1967), p. 89.

2. William M. Alexander, *Are You a Good Teacher?* (New York: Holt, Rinehart & Winston, 1960), p. 48.

3. Lawrence M. Knolle and a Committee of Central School Teachers, *Identifying Superior Teachers* (New York: Institute of Administrative Research, Teachers College, Columbia University, 1959), pp. 22-23.

4. Bennie, op. cit., p. 93.

5. Alan E. Harwood, "Evaluation: The Key to Excellence," *Art Education*, 22, No. 1 (January 1969), 14.

6. Ernest Ziegfeld, "The Final Product—An Expression of Creativity," *Eastern Arts Association Research Bulletin*, 5 (March 1954), 25.

7. "The Curriculum," *National Association of Secondary School Principals' Bulletin*, 45 (March 1961), 10.

8. Edith M. Henry, "Evaluation of Children's Growth Through Art Experiences," in *Art Education* (Washington, D.C.: National Art Education Association, 1963), p. 6.

9. Elliot W. Eisner and David W. Ecker, "How Should Art Performance Be Evaluated?" *Readings in Art Education* (Waltham, Mass.: Blaisdell Publishing Co., 1966), p. 349.

10. Ibid., pp. 400-01.

11. L. deFrancesco, *Art Education: Its Means and Ends* (New York: Harper & Brothers, 1958), p. 202.

CHAPTER 9

1. Leven C. Leatherbury, "The Changing Role of the Professional Organization," *Art Education*, 21, No. 8 (November 1968), 6.

2. Sam Lambert, "NEA and the Real World of Education," *National Education Journal* (December 1967).

3. National Art Education Association, *Exemplary Programs in Art Education* (Washington, D.C.: National Art Education Association, 1969).

4. Edwin Ziegfeld, "Editorial," *Art Education*, 22, No. 6 (June 1969), 4.

5. John A. Michael, "Five Aspects of the Art Curriculum Today," *Art Education*, 21, No. 5 (May 1968), 9.

6. Kenneth M. Lansing, *Art, Artists, and Art Education* (New York: McGraw-Hill Book Co., 1969), p. 15.

7. Hiram Williams, "On Teaching Art," *Art Education*, 21, No. 5 (May 1968), 5.

CHAPTER 10

1. Alex F. Perrodin, *The Student Teacher's Reader: Developing as a Professional Worker* (Chicago: Rand McNally & Co., 1966), p. 414.

2. Wellington B. Grey, *Student Teaching in Art* (Scranton, Penn.: International Textbook Co., 1960), p. 139.

3. "Editorial," *Art Education*, 22, No. 9 (1969), 31.

Bibliography

Books

ALEXANDER, WILLIAM M. *Are You a Good Teacher?* New York: Holt, Rinehart & Winston, 1960.

BENNIE, WILLIAM A. *Cooperation for Better Student Teaching.* Minneapolis: Burgess Publishing Co., 1966.

BROWN, THOMAS J. *Student Teaching in a Secondary School.* New York: Harper & Row, 1960.

BRUNER, J. S. "The Cognitive Consequences of Early Sensory Deprivation," in *Sensory Deprivation*, P. SOLOMAN, ed. Cambridge, Mass.: Harvard University Press, 1961.

CONANT, HOWARD, and ARNE RANDALL. *Art in Education.* Peoria, Ill.: Charles A. Bennett Co., 1959.

CONANT, JAMES B. *The Education of American Teachers.* New York: McGraw-Hill Book Co., 1963.

DEFRANCESCO, L. *Art Education: Its Means and Ends.* New York: Harper & Brothers, 1958.

EISNER, ELLIOT W., and DAVID W. ECKER. "How Should Art Performance Be Evaluated?" in *Readings in Art Education.* Waltham, Mass.: Blaisdell Publishing Co., 1966.

GAITSKELL, CHARLES D., and MARGARET R. *Art Education for the Slow Learner.* Peoria, Ill.: Charles A. Bennett & Co., 1953.

GARTON, MALINDA. *Teaching the Educable Mentally Retarded.* Springfield, Ill.: Charles C. Thomas, 1964.

GREY, WELLINGTON B. *Student Teaching in Art.* Scranton, Penn.: International Textbook Co., 1960.

HENRY, EDITH M. "Evaluation of Children's Growth Through Art Experiences," in *Art Education.* Washington, D.C.: National Art Education Association, 1963.

HILDRETH, GERTRUDE HOWELL. *Educating the Gifted Child at Hunter College.* New York: Harper & Brothers, 1952.

KAUFMAN, IRVING. *Art and Education in Contemporary Culture.* New York: The Macmillan Company, 1966.

KNOLLE, LAWRENCE M., and a Committee of Central School Teachers. *Identifying Superior Teachers.* New York: Institute of Administrative Research, Teachers College, Columbia University, 1959.

LANGER, SUSANNE K. "The Cultural Importance of the Art," in *Aesthetic Form and Education,* MICHAEL L. ANDREWS, ed. Syracuse, N.Y.: Syracuse University Press, 1958.

LANSING, KENNETH M. *Art, Artists, and Art Education.* New York: McGraw-Hill Book Co., 1969.

LARK-HOROVITZ, BETTY, HILDA PRESENT LEWIS, and MARK LUCA. *Understanding Children's Art for Better Teaching.* Columbus, Ohio: Charles E. Merrill, 1967.

LEWIS, HILDA PRESENT. *Art Education in the Elementary School.* Washington, D.C.: American Educational Research Association, 1961.

LUCCA, MARK, and ROBERT KEN. *Art Education: Strategies of Teaching.* Englewood Cliffs, N.J.: Prentice-Hall, 1968.

MASLOW, ABRAHAM H. *Toward a Psychology of Being.* Princeton, N.J.: D. Van Nostrand, 1962.

MUUSS, ROLF E. *First Aid for Classroom Discipline Problems.* New York: Holt, Rinehart & Winston, 1962.

PERRODIN, ALEX F. *The Student Teacher's Reader: Developing as a Professional Worker.* Chicago: Rand McNally & Co., 1966.

SCHENNELLER, JAMES A. *Art/Search and Self-Discovery.* Scranton, Penn.: International Textbook Co., 1961.

SMITH, WALTER. *Art Education, Scholastic and Industrial.* Boston: Osgood & Co., 1872.

WOODY, THOMAS, ed. *Educational Views of Benjamin Franklin.* New York: McGraw-Hill Book Co., 1934.

Articles

"As an Art Teacher I Believe That," *Art Education,* Vol. 2, No. 2 (March-April 1949).

BIBER, BARBARA. "Educational Needs of Young Deprived Children," *Childhood Education,* Vol. 44 (September 1967).

"The Curriculum," *National Association of Secondary School Principals' Bulletin,* Vol. 45 (March 1961).

DIEMERT, HELEN M. "Class: Where Theory Becomes Practice," *Art Education,* Vol. 22, No. 3 (March 1969).

DIFFILY, JOHN. "Course Requirements for Prospective Teachers of Art, 1941-1962," *Studies in Art Education,* Vol. 4, No. 2 (Spring 1963).

EFLAND, ARTHUR D. "Educating Tomorrow's Art Teacher," *Art Education,* Vol. 20, No. 8 (November 1967).

FORMAN, BERNARD I. "Accent on Africa," *Art Education.* November 1968.

GNAGEY, WILLIAM J. "Controlling Classroom Misbehavior—What Research Says to the Teacher," *Art Education.* 1965.

GROPIUS, WALTER. "Letter to the Editor," *Playboy,* Vol. 16, No. 5 (May 1969).

HARWOOD, ALAN E. "Evaluation: The Key to Excellence," *Art Education*, Vol. 22, No. 1 (January 1969).

"Key Concepts from Discussion Groups Responding to Major Speeches at the Pacific Regional Convention," *Art Education*, Vol. 21, No. 6 (June 1968).

LAMBERT, SAM. "NEA and the Real World of Education," *National Education Journal*. December 1967.

LEATHERBURY, LEVEN C. "The Changing Role of the Professional Organization," *Art Education*, Vol. 21, No. 8 (November 1968).

LINDERMAN, EARL W. "Dialogue for Good Teaching," *Art Education*, Vol. 20, No. 7 (October 1967).

MICHAEL, JOHN A. "Five Aspects of the Art Curriculum Today," *Art Education*, Vol. 21, No. 5 (May 1968).

MUNRO, T. B., BETTY LARK-HOROVITZ, and E. N. BARNHART. "Children's Art Abilities: Studies at the Cleveland Museum of Art," *Journal of Experimental Education*, Vol. 11, No. 2 (1942).

National Art Education Association. *Exemplary Programs in Art Education*. Washington, D.C.: National Art Education Association, 1969.

PAGE, RAY, ed. "Education and the Visual Arts," *Illinois Journal of Education*. September 1965.

SCHORR, JUSTIN. "Aesthetic Education for a Change," *Art Education*, Vol. 20, No. 9 (December 1967).

WESTBY-GIBSON, DOROTHY. "New Perspectives for Art Education: Teaching the Disadvantaged," *Art Education*, Vol. 21, No. 8 (November 1968).

WILLIAMS, HIRAM. "On Teaching Art," *Art Education*, Vol. 21, No. 5 (May 1968).

ZIEGFELD, EDWIN. "The Final Product—An Expression of Creativity," *Eastern Arts Association Research Bulletin*, Vol. 5 (March 1954).

_____. "Editorial," *Art Education*, Vol. 22, No. 6 (June 1969).

Papers and Reports

BENZ, JOHN. *The Essentials of a Quality School Art Program: A Position Statement*. Washington, D.C.: National Art Education Association, 1968.

FISCHER, JOHN H. Speech at Fifteenth Annual Meeting of American Association of Colleges for Teacher Education. Chicago, Illinois.

FOSHAY, ARTHUR W. "Changing Goals and Art Education." Conference on Curriculum and Instruction Development in Art Education: A Project Report. ALICE A. D. BAUMGARNER, Director. National Art Education Association, 1967.

Identifying Superior Teachers. A report of a study by Central School Boards Committee for Educational Research, Institute of Administrative Research, 1959.

JOHNSON, IVAN. "The Basis for Art Teacher Preparation," *Report of the Commission on Art Education*, JEROME J. HAUSMAN, ed. Washington, D.C.: National Art Education Association, 1965.

A *Position Statement by the National Art Education Association*. Washington, D.C., 1968.

Research Monography 1963-M. *Music and Art in the Public Schools*. National Education Association, August 1963.

SCHULTZ, HAROLD A. "The Teacher of Art," *Report of the Commission on Art Education*, JEROME J. HAUSMAN, ed. Washington, D.C.: National Art Education Association, 1965.

"Who's in Charge Here?" Discussion paper, National Commission on Teacher Education and Professional Standards. National Education Association, 1966.

Why Art Education? Brochure, Publication Division of National Education Association. Stock No. 051-02096.

ZIEGFELD, EDWIN. *National Education Association Project on the Academically Talented Student*. Washington, D.C.: National Education Association, 1961.

―――. "The Current Scene: Problems and Prospects for Art Education Today," *Report of the Commission on Art Education*, JEROME J. HAUSMAN, ed. Washington, D.C.: National Art Education Association, 1965.

Yearbook

McFEE, JUNE KING. "Art for the Economically and Socially Deprived," *Sixty-Fourth Yearbook of the National Society for the Study of Education*. Chicago, 1965.